YARMOUTH &
GORLESTON

THROUGH TIME

Frank Meeres

AMBERLEY PUBLISHING

First published 2009
Reprinted 2012

Amberley Publishing
The Hill, Stroud,
Gloucestershire, GL5 4EP

www.amberley-books.com

British Library Cataloguing in Publication Data.
A catalogue record for this book is available from the British Library.

ISBN 978 1 84868 456 0

Typesetting and Origination by Amberley Publishing.
Printed in Great Britain.

Contents

Introduction

Yarmouth rightly insists on calling itself 'Great' and has done so for 800 years. This was originally to distinguish the town from 'Little Yarmouth' across the river Yare: the area that is now called Southtown. The town stands on a sandbank, which only emerged from the sea about 900 years ago. As soon as the sand was dry enough, fishermen settled on it. At first they built rough boathouses and lived in temporary huts, only in use during the fishing season, a form of settlement that was common in those times. Very rapidly, the temporary settlement became permanent, and one sign of this is the establishment of a parish church to cater for the spiritual needs of the fisher folk – and to collect the tithes due to the church: a portion of every boatload of fish caught was claimed by the local rector. A trading market soon followed. This was on the very same site as the present day market, which is the largest open-air market place in England. By 1209, the town was important enough to be given its first royal charter, by King John. Yarmouth became one of the most important towns in England in the Middle Ages, as a fishing town and port. Apart from St Nicholas' church, other buildings in Yarmouth from the Middle Ages are also worth going to visit, including the Tolhouse, which is the oldest civic building in Britain, and the town walls with their prominent towers, shown in several images in this book. All the houses in the town were inside the circuit of these walls, a very small area which led to people living in narrow and increasingly crowded alleys running in parallel lines – the famous Rows of Great Yarmouth.

For centuries there was nothing outside the walls, but 250 years ago something happened that changed the character of the town forever – people began to bathe in the sea! This led to the development of the sea front and this process expanded enormously one hundred years later with the coming of the railway. Now people from Norwich could easily visit Yarmouth in a day, and excursion trains were very soon running from London and from the big cities of the Midlands. Fashions on the beach have changed enormously over 150 years as the photographs in this book show. Visitors needed more than just the sea, however: they required other forms of entertainment. First came the piers, the Britannia and the Wellington. In between them was a third 'pier', the Jetty, originally for practical purposes rather than pleasure (fishing-boats landed their catch here). The boats were eventually moved onto the river rather than the sea front, and the Jetty became a third pier, though without the varied entertainments that featured on the other two.

Entertainments were also needed for wet days – sadly not that uncommon in a British summer! Some of these are featured in this book – the Revolving Tower, the Winter Gardens, the Waterways and, more recently, the Marina and Sea Life, to name just a few of many. These too have changed according to the tastes of different generations.

Meanwhile, Gorleston, across the Yare, has also flourished. This is on higher ground and there were people living here when Yarmouth was still beneath the sea. It was both a fishing port and a centre for shipbuilding. It became a seaside resort as well, but has always been less boisterous than its neighbour, refusing to develop nearly as many amenities and relying instead on its quieter beauty.

There has been a great change in the last fifty years. The Rows have disappeared and the people who lived in them now live across the river in new houses in Gorleston, Bradwell and Belton. The fishing has gone now, but the wonderful Time and Tide museum tells the fishermen's story. However, the holidaymakers still come to enjoy three miles of golden sands and the activities along the sea front. The town is continuing to develop as a port as well, looking across the North Sea to our neighbours in Europe. As I am writing this book, the new Outer Harbour is being opened: a sign of the town's confidence in its future.

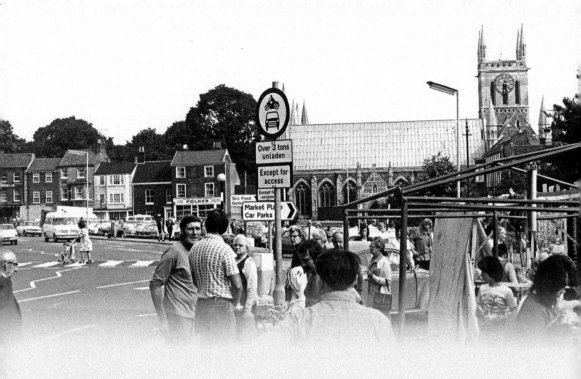

chapter 1

Historic Yarmouth

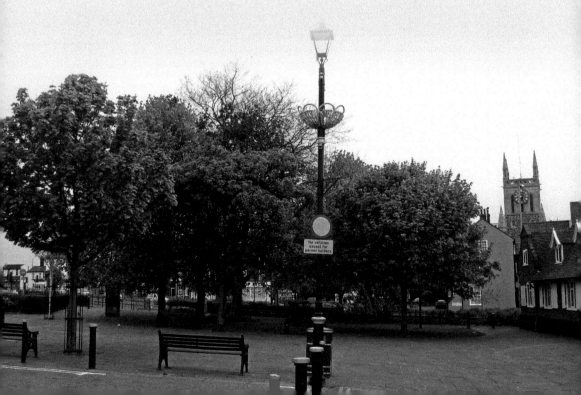

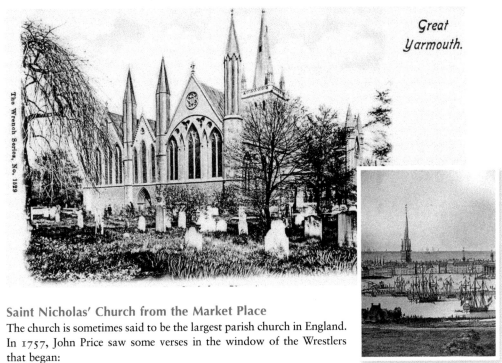

The Wrench Series, No. 1529

Saint Nicholas' Church from the Market Place

The church is sometimes said to be the largest parish church in England. In 1757, John Price saw some verses in the window of the Wrestlers that began:

> *The Yarmouth girls are one and all*
> *Straight as their steeple though not quite as tall.*

The point of the poem is that the spire at that time was not straight but twisted! That spire was replaced in the early nineteenth century with a shorter spire, which was itself destroyed by bombs in 1942.

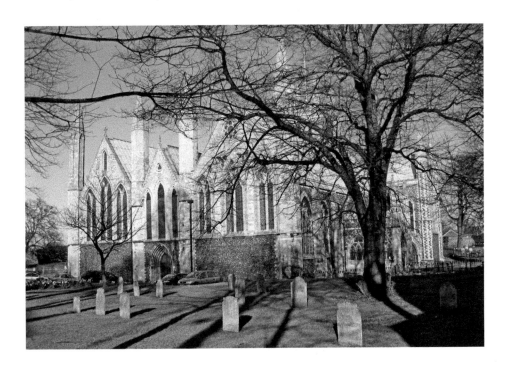

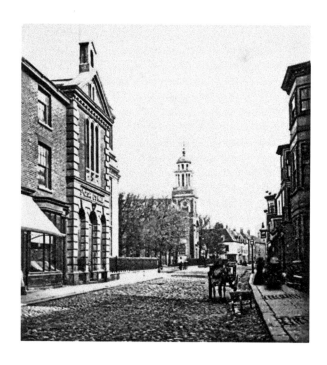

Saint George's Chapel

St George's Chapel was built in 1715 and cost £5,861. One hundred years later, the congregation consisted of between 700 and 800 people. By the Second World War, numbers had dwindled and the chapel was closed in the 1950s, the last service being held here on 8 March 1959.

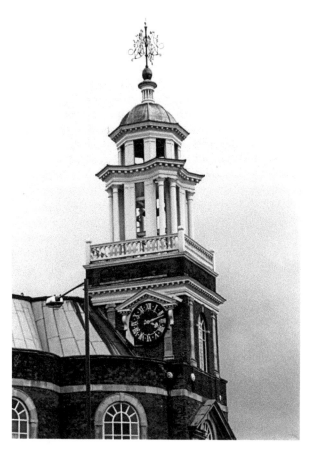

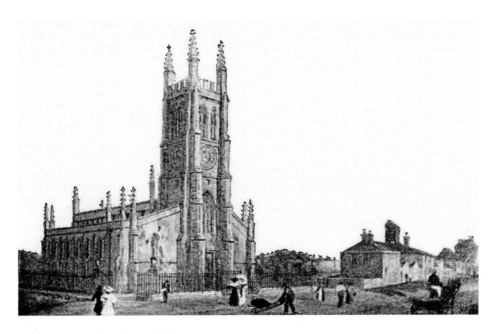

Saint Peter and Saint Spiridon

The first stone of Saint Peter's church was laid on 7 June 1831. It was designed to hold 1,800 people and cost £12,000. It is now used by the Greek Orthodox community in the town and dedicated to Saint Spiridon. The Greeks, mainly from Cyprus, have added a welcome diversity to the modern town.

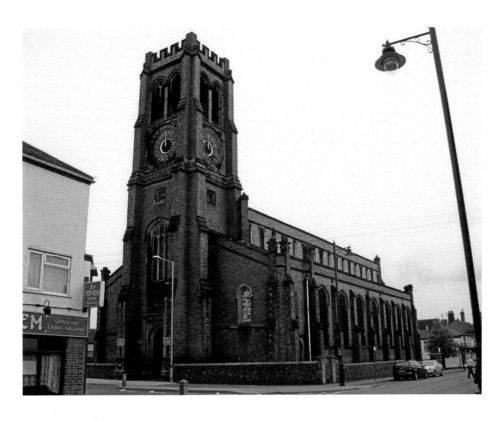

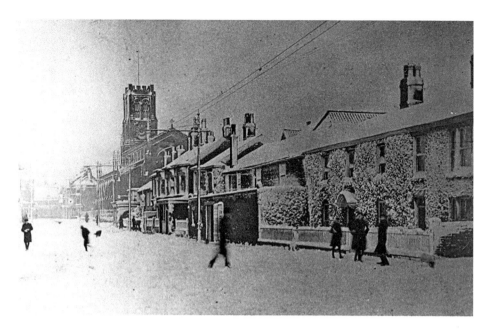

Saint Peter's in Snow and Sunshine

In May 1860, one of the turrets shown in the last picture was blown down, and the others were then removed. Saint Peter's was the first church in Britain to suffer air-raid damage, being slightly damaged in the Zeppelin raid on the town on 19 January 1915. Two people died in nearby streets in this raid, the first-ever fatalities of a bombing raid in Britain. The snowy scene was taken at Christmas in 1906.

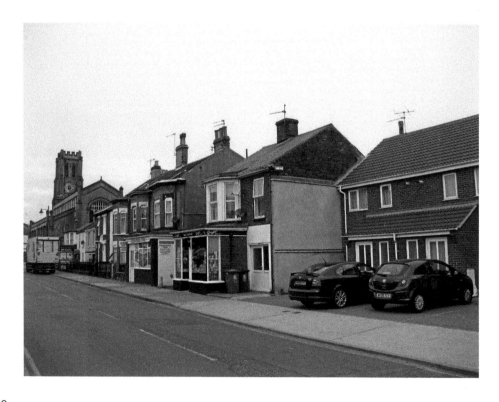

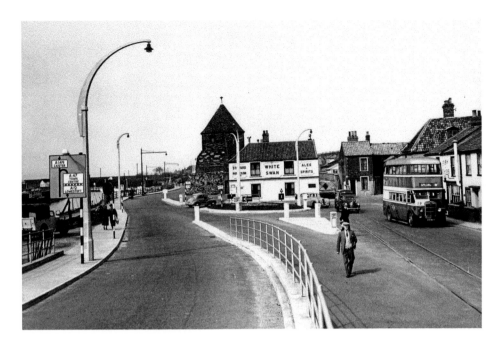

The North-West Tower and the Swan

The tower is the North-West Tower, the northern limit of the medieval town wall, which ran east behind the Swan and on the line of the terraced houses to the right, to the churchyard and the North-East Tower. The wall then ran to the south to the towers shown in other pictures in this book. It then turned sharp right and ran due west to the river.

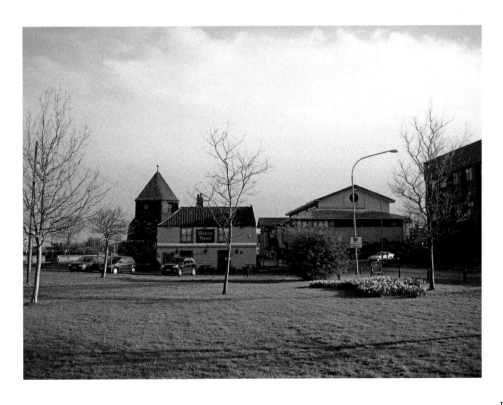

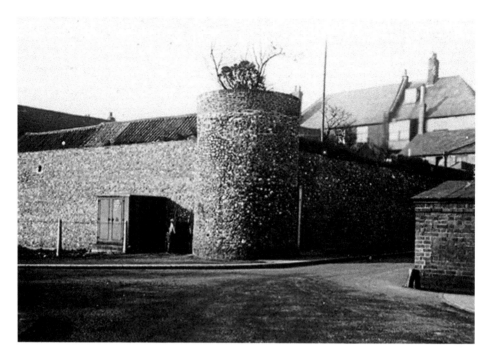

The North-East Tower

Only five minutes walk from the busy Market Place, this is one of the parts of central Yarmouth where the town walls can be seen most clearly; we are standing outside the medieval town, facing what the Tudor poet Thomas Nash called 'a flinty ring of sixteen towers ready to send out thunder to any Spaniard who dared to come near'. Today, Spanish visitors are most welcome in Yarmouth, along with visitors from every country!

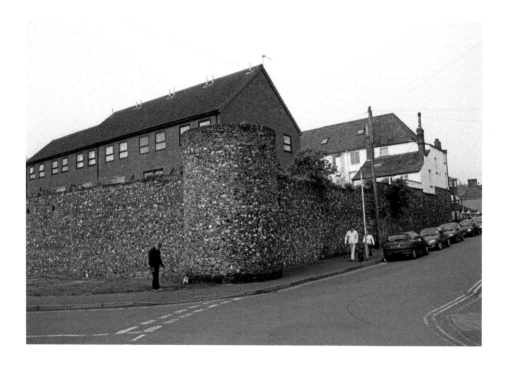

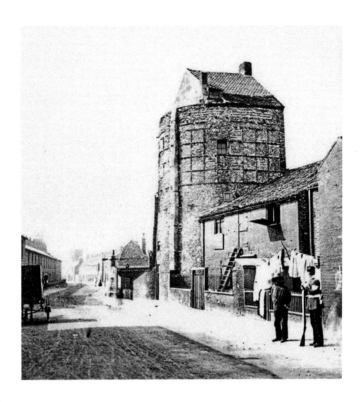

The South-East Tower

The chequer-board pattern on this tower, in brick and flint, is a striking decorative feature and one that was repeated on the South Gate of the town; the gate was pulled down at the end of the eighteenth century. This tower is only a very short distance from the Time and Tide Museum.

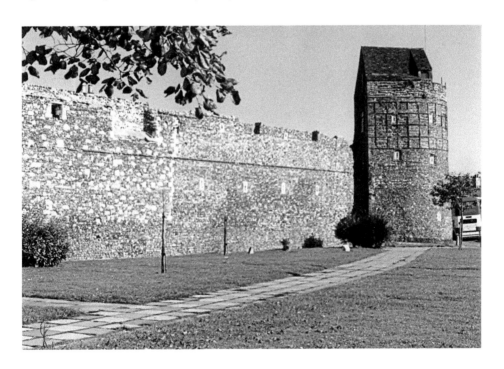

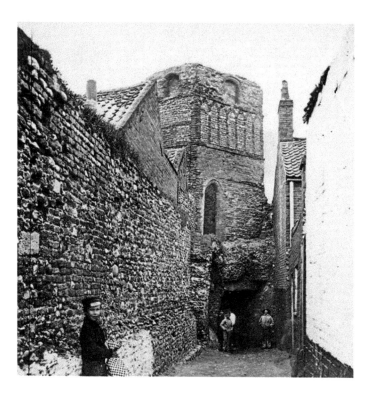

Blackfriars Tower

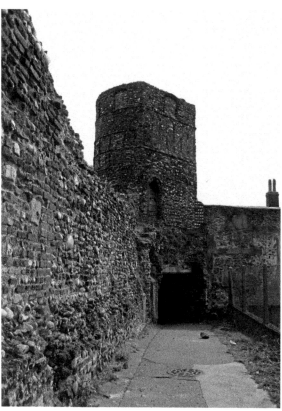

As long as the town walls were thought necessary for defence, every effort was made to stop people building houses beside them, but by the nineteenth century many buildings had been erected against the walls. Most have been pulled down to show the town walls in all of their glory – one of the finest surviving urban defences in England, and little known to the many thousands of summer visitors to the town.

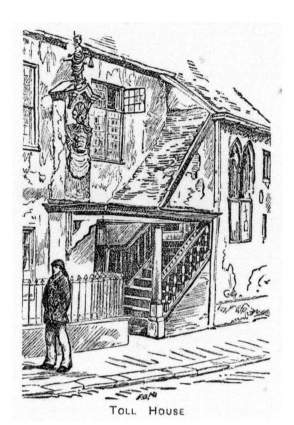

TOLL HOUSE

The Tolhouse

The Tolhouse is one of the oldest buildings in Yarmouth and the oldest civic building in England. It has an open external staircase, leading up to the main room of the building on the first floor. The common prison was in the basement of the Tolhouse, which is now a museum. The building was badly damaged in the Second World War.

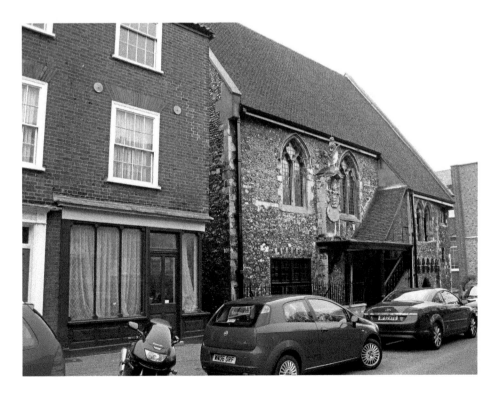

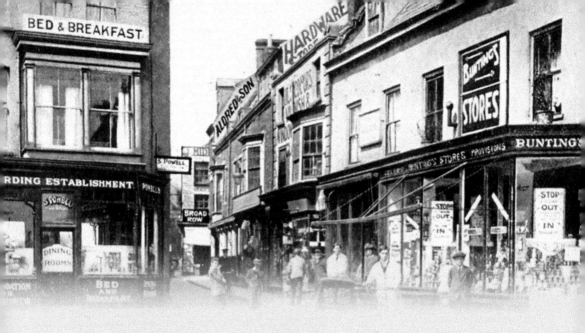

The Rows of Great Yarmouth

Row 99

The Rows are narrow and dark parallel lanes that run between the three main north-south streets in the heart of Great Yarmouth. There were 145 of them, and their total length came to 7 miles. They had had nicknames, after a tenant or a local public house. In 1804, they were given numbers, starting with those at the north end of the town and working southwards. A special cart was developed to carry goods through these narrow passages. The Rows were pulled down during slum clearance, assisted by bomb damage to the area in the Second World War.

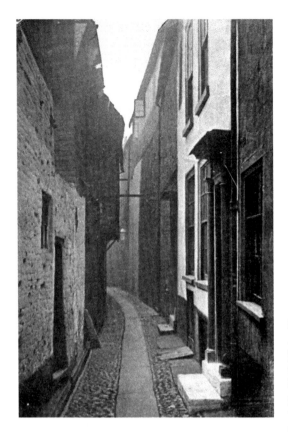

Kitty Witches Row

At one end, Kitty Witches Row was just 30in wide, the narrowest of all the rows in Great Yarmouth. No one knows where the name comes from, perhaps from the 'kitty witches' who were a gang of local women given to drunken rowdiness, minor violence and petty theft – no fun to meet them in this dark alley after nightfall!

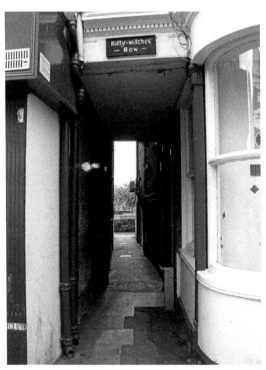

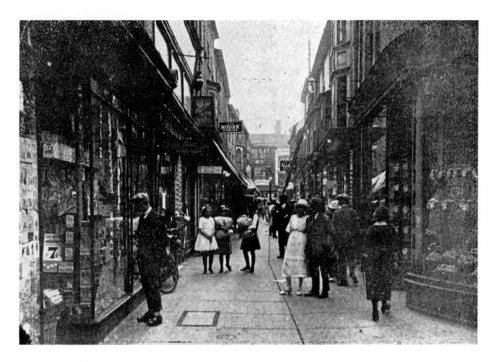

Inside Broad Row

Broad and Market Rows are the only 2 of the 145 rows to survive in a complete state and they are not typical: most of the other rows were much narrower, and were made up of houses rather than shops. Traders in the Row included Lamberts, the tea dealers. Broad Row was badly damaged by fire recently, but has been lovingly restored under the guidance of the Borough Council.

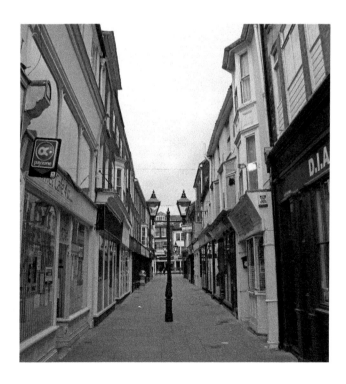

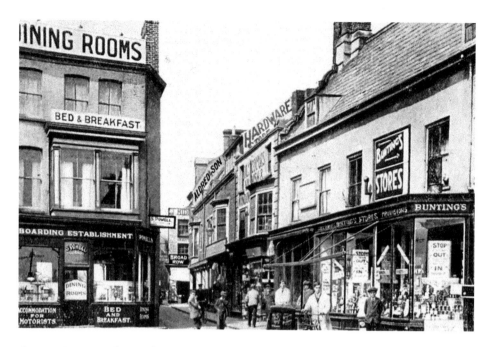

George Street and Broad Row

The boarding establishments boasts of 'accommodation for motorists' – but cars were still a rare phenomenon in the Yarmouth streets in the early twentieth century. There has recently been a return to the position of 100 years ago with an increasing number of pedestrian-only streets in the town centre.

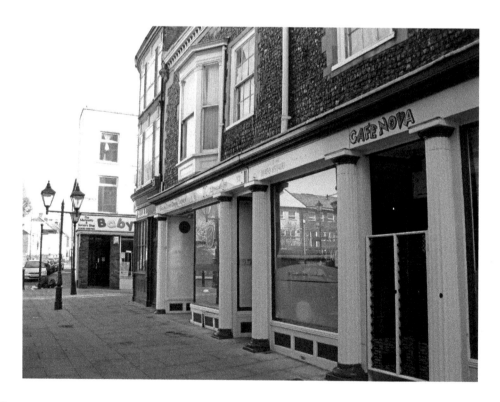

Market Row

The entrance to Market Row is both a short cut to the Market Place and a popular shopping street in its own right. The historic photograph shows the well-known firms of Bretts the finishers and Stead and Simpson's boot-sellers with, beneath the Central Liberal Club, a general store called the Chest of Value, goods one penny. This is the Poundland of a century ago and it shows what inflation has done to prices!

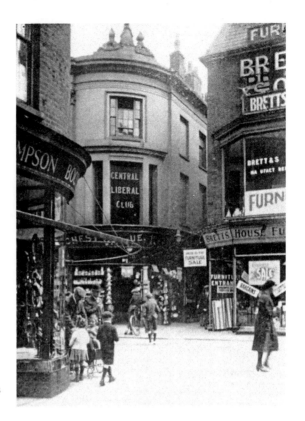

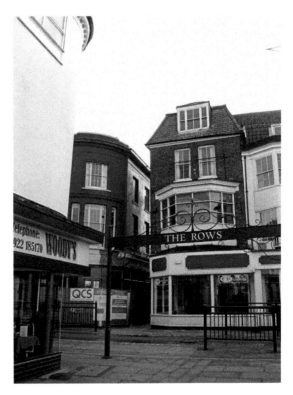

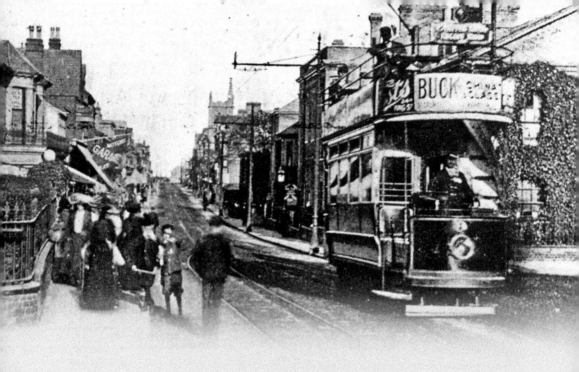

The Heart of the Town

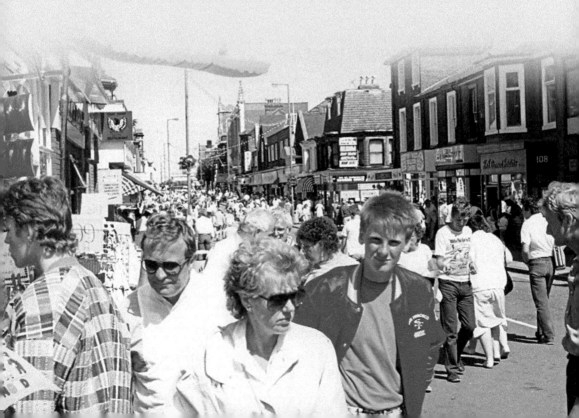

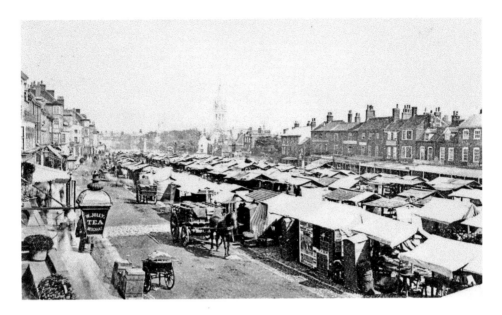

The Market Place

A 1906 guide book says of the market: 'On its stalls are exposed in tempting array the rich produce of the fertile counties of Norfolk and Suffolk, brought hither by buxom farm-wives and cream-complexioned cottagers, whose appearance is as good a testimony to the health-giving purity of the East Anglian air as the quality of the poultry, fruit and vegetables is to the richness of the soil.' Has the market changed over the last century?

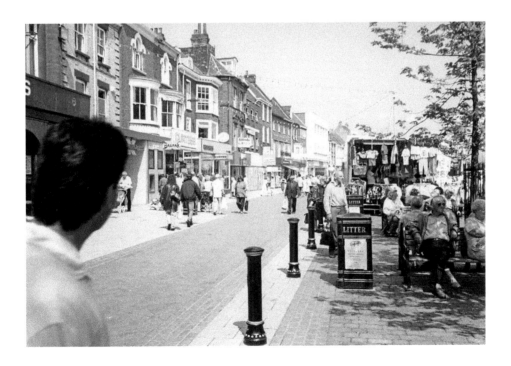

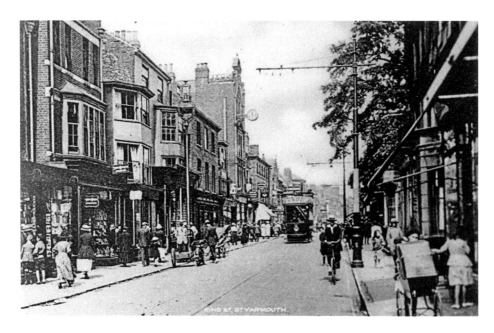

King Street

King Street runs along the central spine of Great Yarmouth, from its highest ground in the Market Place southwards. It has been the town's main shopping street for generations. A visitor from Oxford, John Price, described King Street in 1757 as 'a long handsome street and of a proper width, on each side a range of houses and shops, built with brick in general, sashed, neat and uniform'.

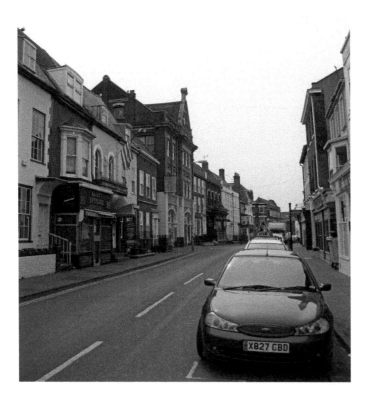

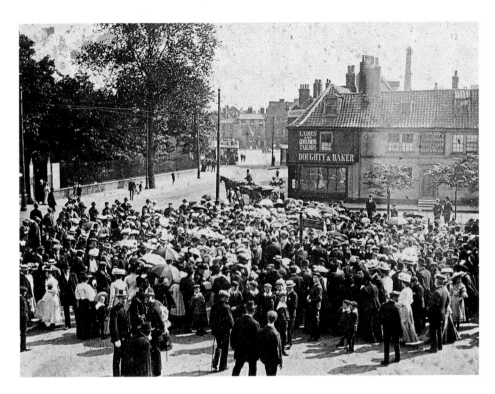

Church Plain

The historic photograph shows a public meeting in Church Plain in 1907. The churchyard is behind the trees on the left, surrounded by a high fence which was put in almost two centuries ago and was to deter people from stealing bodies from the churchyard to sell to anatomists in London. One of the rows near here even became known as 'Body-Snatchers Row'.

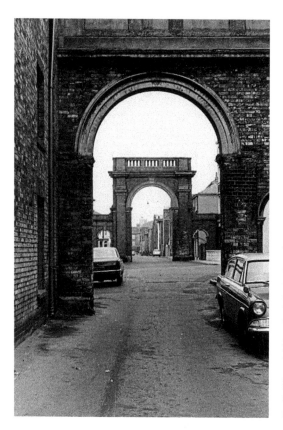

Underneath the Arches

These arches across the streets are not as well known to Yarmouth people as they might be. They reflect an era of a century and a half ago, when the Victoria Building Company of Great Yarmouth was trying to develop this part of the sea front for high-class housing. The Arches were built in 1846 and 1847, and the larger one, known as the Wellington Arch, was intended as the grand entrance to the estate.

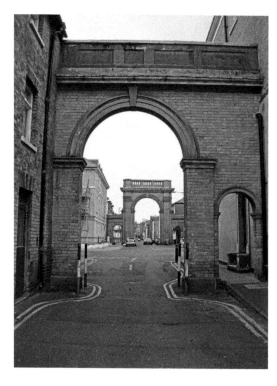

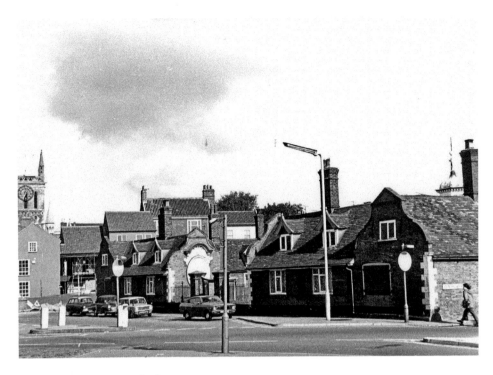

The Fishermen's Hospital

The Fishermen's Hospital was built for 'decayed fishermen' in 1702. The statue in the yard is of 'charity' and was once Yarmouth's only statue. As I write this book in 2009, a new statue showing a boat is to be erected in front of the hospital to commemorate Yarmouth's first royal charter, which marked the start of Yarmouth as a great trading town.

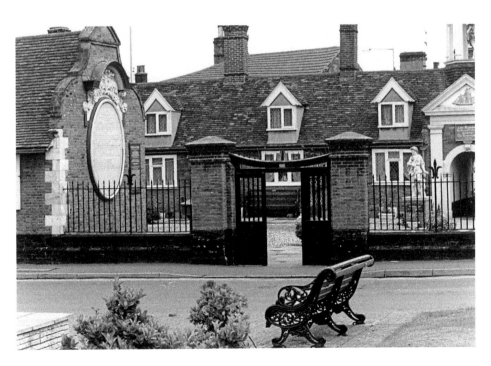

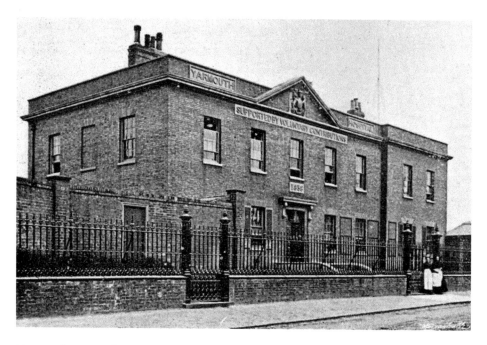

Yarmouth General Hospital

Yarmouth's own hospital was built in 1839 and cost £1,600 to build. It had room for just twelve in-patients. The hospital stood on the mound or ravelin that was part of the sixteenth-century defences of the town, a place where cannons facing out to sea once stood. It was enlarged half a century later: the new hospital was opened by Sir James Paget, after whom the present hospital is named, on 20 September 1888. The hospital closed in 1981 and has been replaced with apartments.

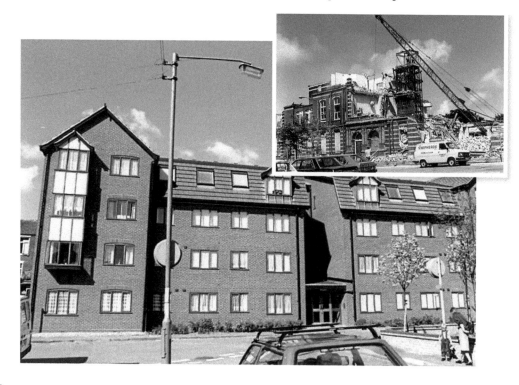

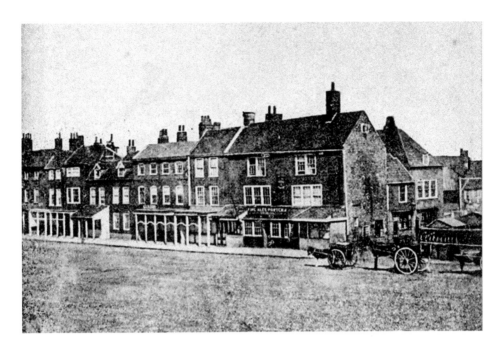

The Butchery

The butchery always had a special place within a town market to sell fresh meat which was generally known as the Shambles. The Shambles on the east side of Yarmouth Market Place were built in 1551, and after that date all the town butchers had to sell their wares there. Country butchers also sold meat in the Shambles, but only on market days and they were ordered that they had to bring beef to sell as well as veal!

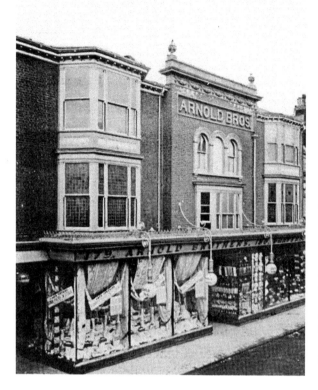

Shopping at Arnolds'

The Arnold brothers were drapers, and their shop was founded in Yarmouth in 1869. At the time of this photograph, taken in 1897, it boasted a newly-arranged dress department, millinery, mantle and ladies' outfitting show-rooms, as well as a carpet warehouse. The King Street shop was devastated by fire in 1919.

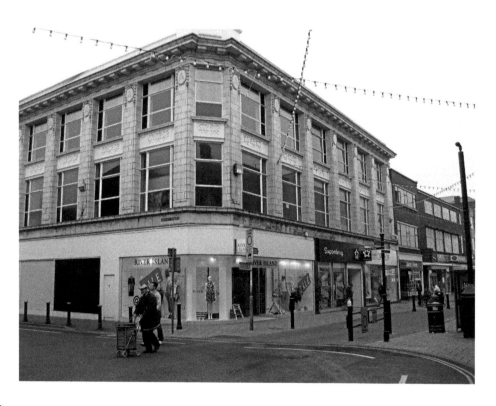

Yarmouth's General Store: Palmer's

Palmer Brothers have been a major department store for well over a century. In 1897, they advertised: 'The Public are invited to view the Premises, which are now admitted to be the finest in the Eastern Counties, covering a ground space of 16,000 square feet, and absorbing four Front Shops, and 25 other properties, and fitted throughout in Natural Woods'.

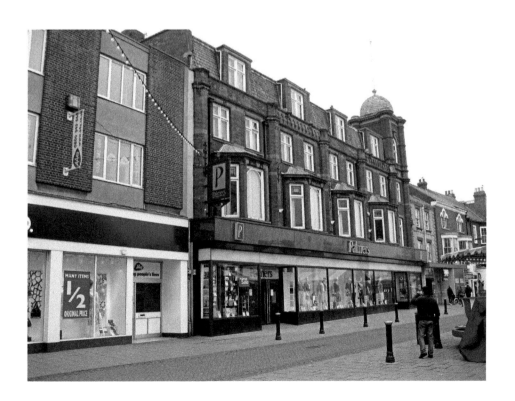

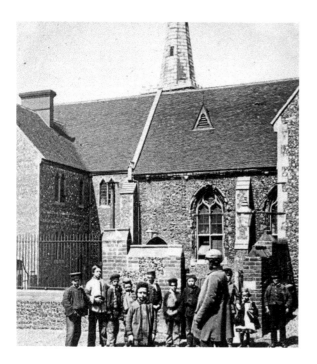

The Priory School

The hall of the medieval priory was re-used as a charity school for poor children in the 1840s. The church of Saint Nicholas can be seen behind; the original priory was for monks who served the church. The school buildings were once haunted by the ghost of an Egyptian mummy, a story to be told in full in my forthcoming book, *Paranormal Norfolk*!

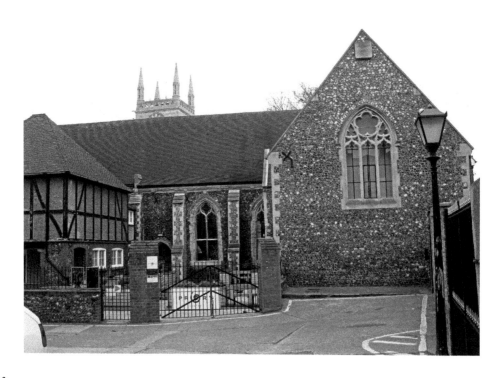

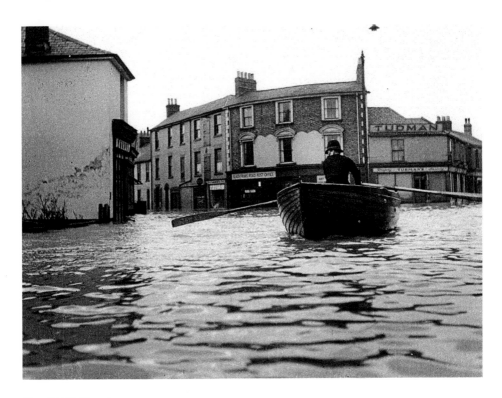

The 1953 Floods

The storms of 31 January 1953 and the floods that they brought are an essential part of the history of Great Yarmouth and Gorleston, still remembered by older residents. Several pictures in this book record their impact. Scenes like this one at the bottom of Havelock Road are almost impossible to imagine in the Yarmouth of today. But, with rising sea levels, they *could* be a sign of things to come!

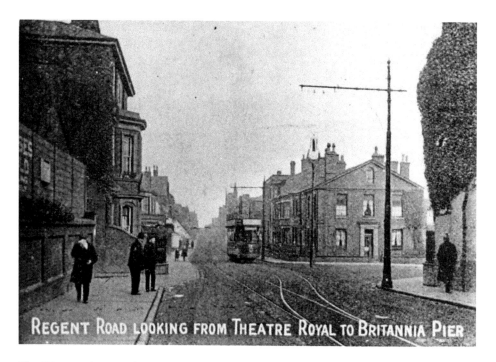

REGENT ROAD LOOKING FROM THEATRE ROYAL TO BRITANNIA PIER

The Way to the Beach

Regent Road is the link between the town centre and the sea front, and was at one time swamped with motor traffic. Pedestrianisation has totally changed its character, restoring it to the old-world peace of the times when the only powered traffic was the tram. The tower that can be seen on the right is that of the Roman Catholic church built in 1850 when this street had a very different character, and now it brings the church into the heart of holiday Yarmouth.

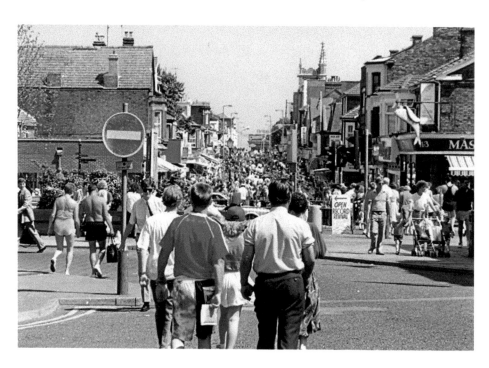

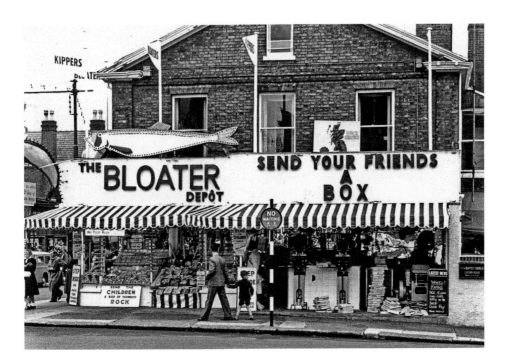

Shopping in Regent Road

In the heyday of Great Yarmouth, it was customary for holidaymakers to take or send home a box of Yarmouth bloaters: a bloater is a full herring slightly salted and smoked. Yarmouth people still recall fondly the Scottish girls who came to town in the fishing season, gutting the herring and putting them in barrels with incredible rapidity: the barrels of fish were usually exported.

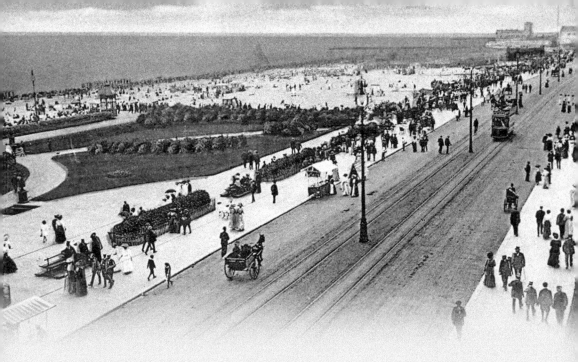

Beside the Seaside:
Three Golden Miles

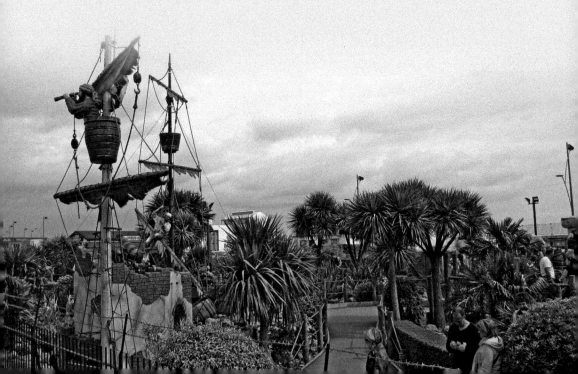

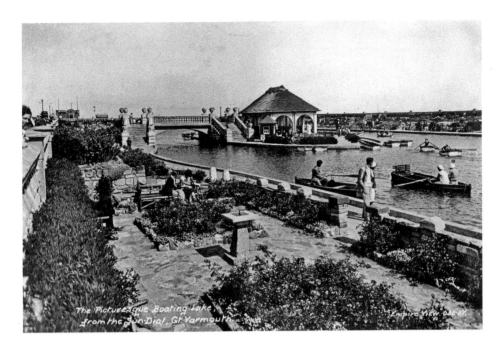

The Boating Lake

Something on the lake seems to have caught the attention of most of the people in this image, perhaps the traditional call of 'come in, number five, your time is up!' The people on the extreme left are on the parade; the beach and the sea are immediately behind the wall on the far side of the lake. Sadly, the sundial has disappeared over the intervening years between the images.

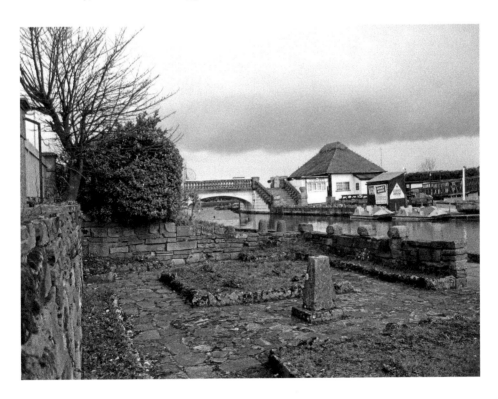

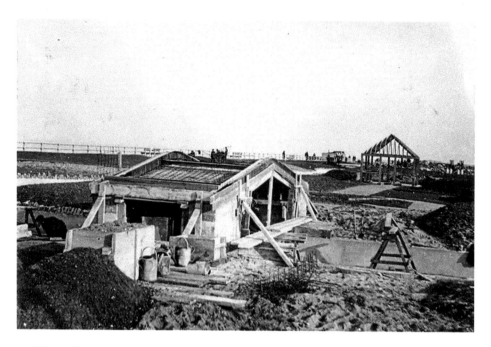

Building The Waterways

The Venetian Waterways were built in the 1920s as part of a scheme to provide work for the unemployed. This is one of a series of unique photographs by the Borough Engineer showing the actual process of building. Today, the area is one of the most peaceful parts of the sea front, and it is easy to see why seventy years ago Arthur Mee called Yarmouth 'a great natural playground, a quick-change sanatorium for jaded mortals'.

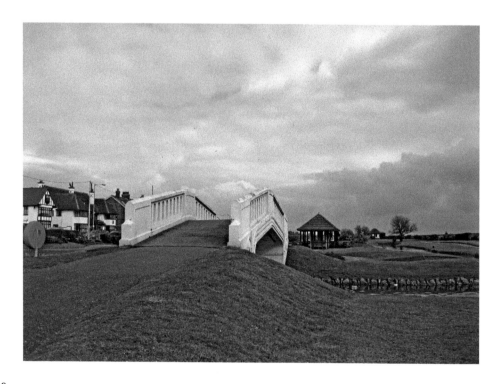

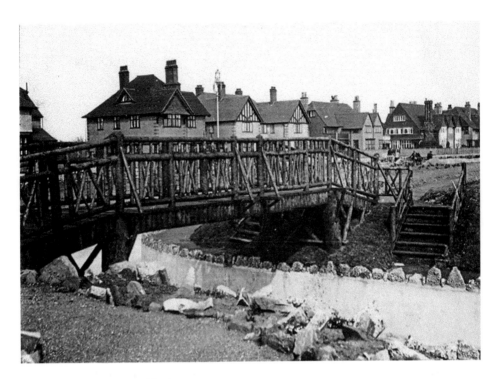

A Bridge Over Untroubled Water

When the aquarium was built it was intended to mark the northern limit of the Marine Drive along the sea front. Since then, the activities along the front have expanded northward to the Waterways, the Boating Lake and beyond, but without the frenetic activity of the front further south, a place to stroll and enjoy the Yarmouth sunshine. The scene became more active in 1935, when the borough council allowed the waterways to open on Sundays for the first time.

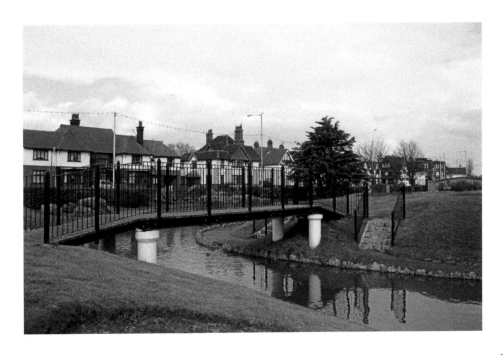

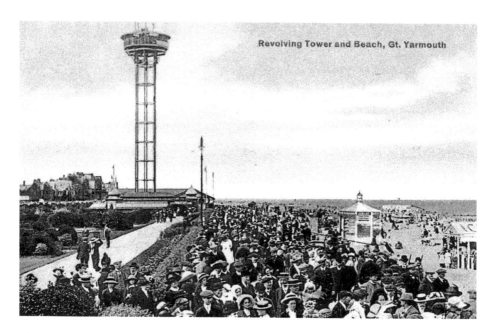

Revolving Tower and Beach, Gt. Yarmouth

The Revolving Tower and the Beach

The Revolving Observation Tower was built in 1897, and was 130ft high. The car, which turned round as it rose and fell, could carry 150 people. The fixed observation platform at the top held forty to fifty people and on a clear day the spire of Norwich cathedral, twenty miles away, could be seen. In 1941, the tower was demolished to provide metal to make armaments. This was part of a nation-wide project in which many metal fences were lost, but those around Yarmouth churchyard survived.

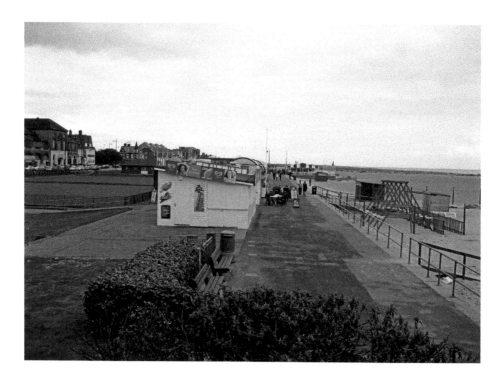

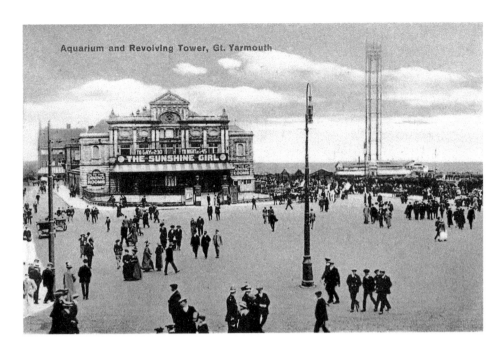

Aquarium and Revolving Tower, Gt. Yarmouth

The Aquarium and the Tower

The aquarium opened in 1883 and became a theatre in 1896, although a few of the fish tanks were retained, an early version of the modern Sea Life. Oscar Wilde once gave a lecture here. It became a cinema in 1914 and also hosted popular musical comedies and later live-music groups. It was renamed the Royalty in 1982 and the Hollywood in 1992.

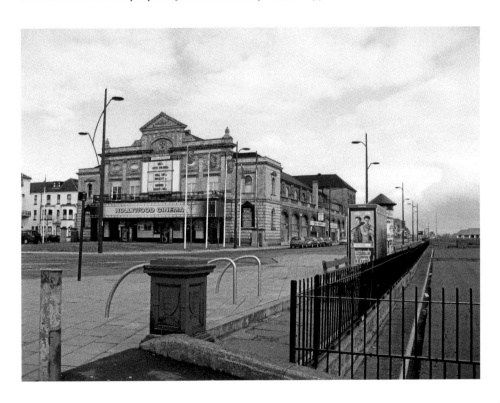

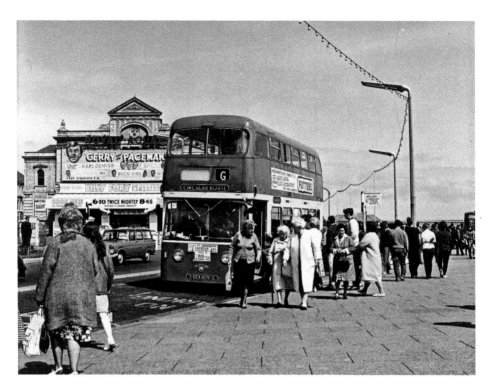

Gerry and the Pacemakers or Hannah Montana?

The aquarium boasts a live show by Gerry and the Pacemakers in the older image, while a film starring Hannah Montana was showing when the modern photograph was taken. Is her moment of fame a brief one, or in half a century will she be remembered with nostalgia, as the rock stars of the 1950s and '60s are by the pensioners of today?

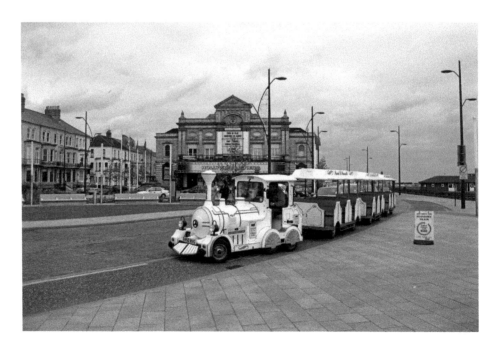

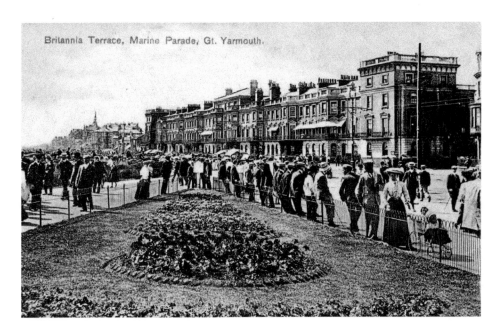

Britannia Terrace, Marine Parade, Gt. Yarmouth.

Britannia Gardens and Terrace

The crowded sea front just south of the Britannia Pier. The houses were built in about 1850 as high quality buildings. Most of them are now cafés on the ground floor, but the upper floors, with their balconies, french windows and stucco decoration, still reflect the high-class character of this block of buildings. If the holidaymaker only looks up beyond the ground floor, there is an enormous amount of history to be seen along the sea front of Great Yarmouth!

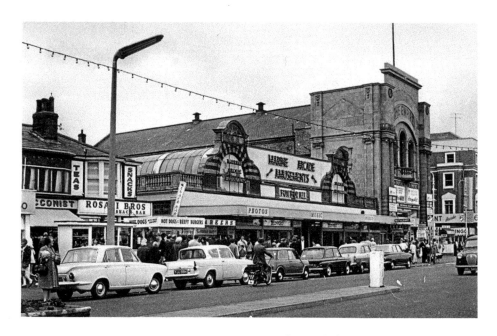

Amusement Arcades and The Empire

The two buildings here capture the essence of past and present Great Yarmouth. The two semi-circular arches in the left hand building mark the entrances to the Marine Arcades, built in 1902 and 1904 and originally containing twenty shops, all catering for the holiday trade. The Empire Cinema opened in 1911. It was then described as a 'handsome terracotta elevation, the striking features of which are lofty columns and a large semi-circular balcony'.

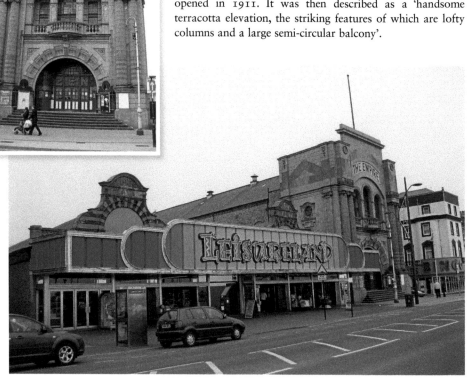

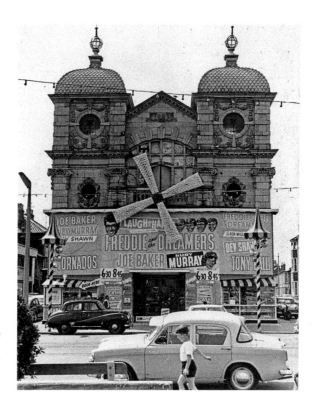

A Gem of a Windmill

This cinema was originally called the Gem and was the first in Great Yarmouth and among the earliest in England. It opened in 1908, and was managed by the impresario C.B. 'Cocky' Cochran, and originally men and women had to sit on separate sides of the auditorium! It was renamed the Windmill in 1945.

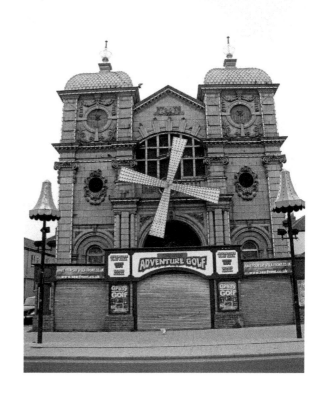

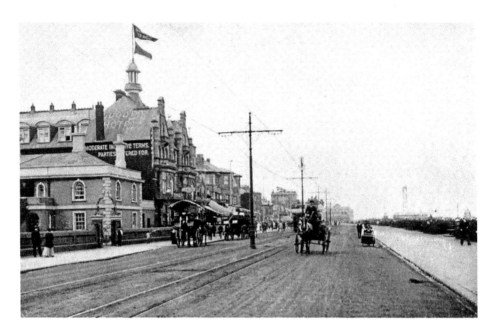

Goode's Hotel

Goode's Hotel and ballroom opened in July 1902, on the site of Winton's Rooms, a dancing academy that had been destroyed by fire on the evening of 5 September 1901 and which had been owned by John Goode and his brother from about 1896. Edward Winton's name could be seen in the coloured glass over one of the doors until 1972. The Tower Hotel next door was built in 1964.

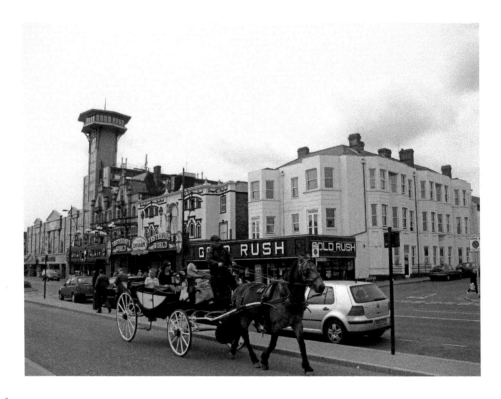

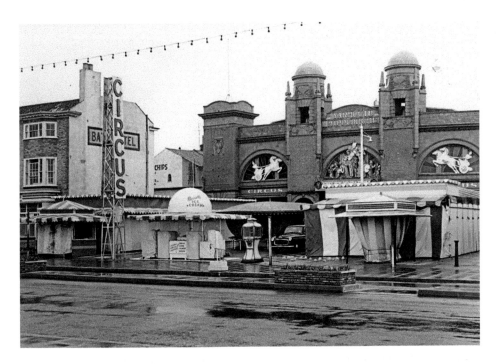

Hotel and Hippodrome

To the left is the remaining part of the Bath Hotel, the rest of which was pulled down so that the Hippodrome could be seen from the sea front. Built in 1835, it replaced the first building for the visitor ever built upon Yarmouth's Golden Miles: the Bath House of 1759. The 1980s structure in front has once again blocked the view of the Art Nouveau terracotta glories of the Hippodrome, built by George Gilbert.

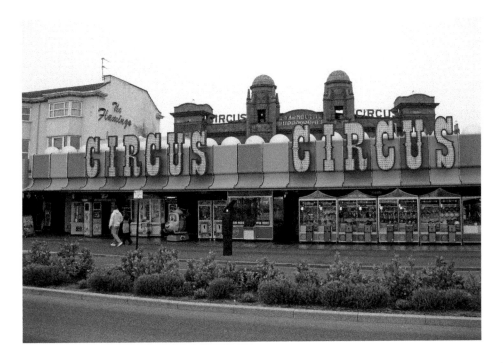

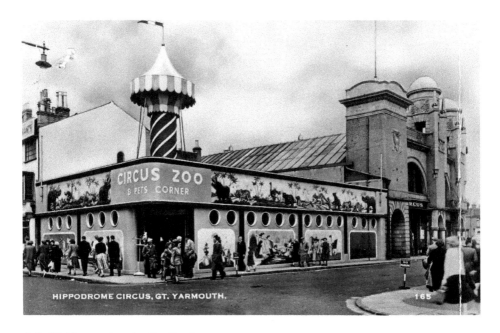

HIPPODROME CIRCUS, GT. YARMOUTH.

165

'It's All Happening At the Zoo'

The Hippodrome was built in 1903 at a cost of £20,000. It is one of only two purpose-built circus buildings in England (the other being at Blackpool). At first, it was used by a circus in the summer and as a cinema in winter. After the Second World War it became exclusively used by the circus. The Zoo, shown here in a 1966 photograph, can only have been a very small one – despite the excitements promised by the frieze around it – but it certainly seems popular!

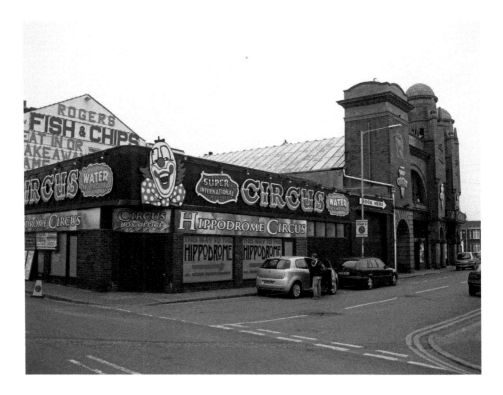

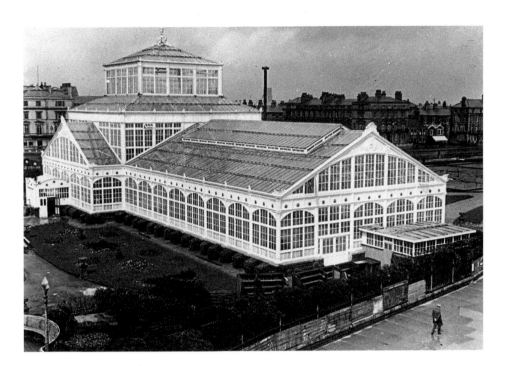

A Present from Torquay – The Winter Gardens

The Winter Gardens was originally built in Torquay in 1878-91. It was transported to Yarmouth and re-erected in 1903; they paid £1,300 for it, just one tenth of its original cost, but it must have been difficult and costly to transport across the entire width of England! However, it has certainly paid for itself many times over as a place to go on a wet and cold Yarmouth day. It has had many uses: at one time it was used as a skating rink, and later as a German-style beer cellar.

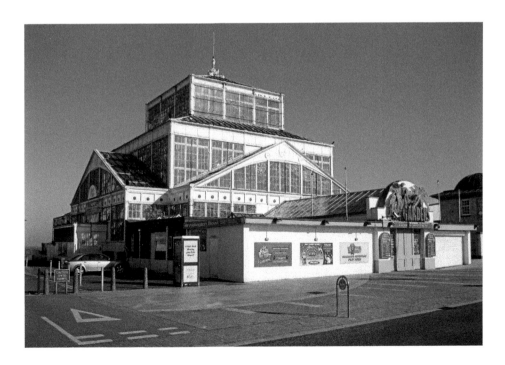

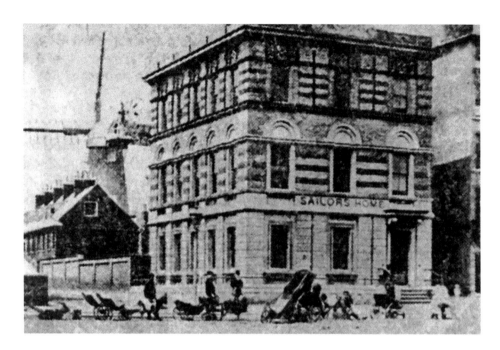

The Jetty Mill and the Sailors' Home

This poor-quality photograph is unique, showing the last of the windmills to survive in central Yarmouth. The Sailors' Home was built in 1859 as a refuge for shipwrecked sailors; readers of *Robinson Crusoe* will remember that the hero was cared for in Yarmouth after being shipwrecked off the Norfolk coast. The boys in front of the home are offering children rides in carts pulled by goats, a form of entertainment banned before the First World War in an early contribution to animal welfare.

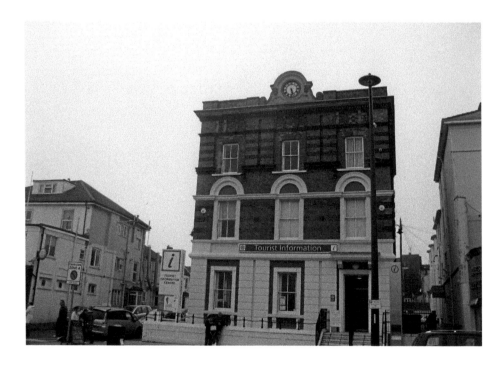

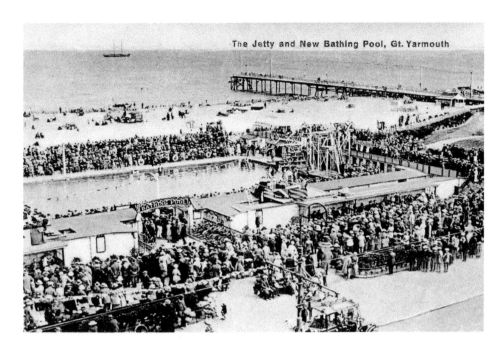

The Jetty and New Bathing Pool, Gt. Yarmouth

Bathing on the Seafront

With the sea so near, why bathe in a swimming pool? Even when bathers first came to Yarmouth in the 1750s, they did not go into the sea but to baths in the Bath Hotel up to which the health-giving sea water was piped. The original swimming pool on the sea front was built in the 1920s, to cater for those days when the sea was too rough for enjoyable swimming, and it, too, contained sea water! In the 1980s it was replaced by the Marina – where the pool is heated and indoors!

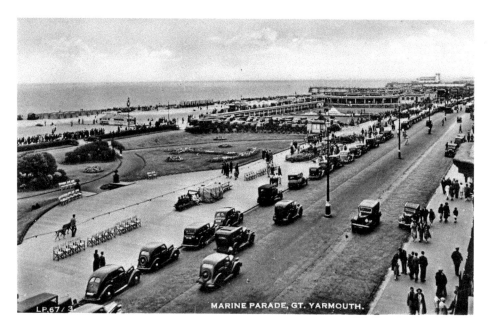

MARINE PARADE, GT. YARMOUTH.

Along the Marine Parade

Yarmouth sea front is here seen in the hey-day of the motorcar. Many attractions have since been built between the road and the beach, and Great Yarmouth Sea Life Centre is one of the most popular, allowing close encounters with the some of the most beautiful and the scariest creatures of the deep – from behind the safety of a glass wall.

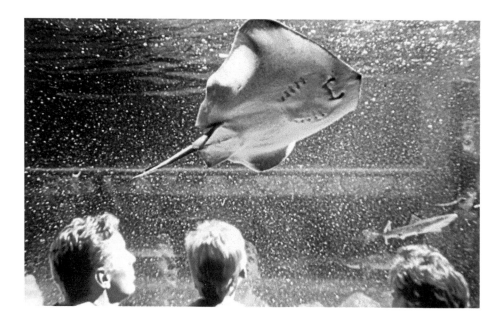

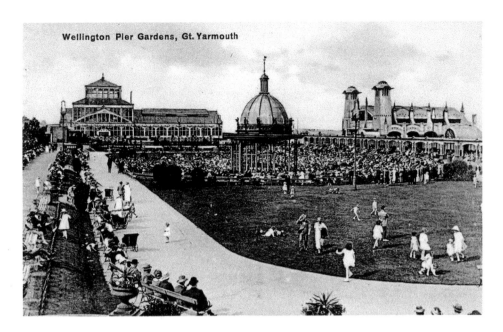

Wellington Pier Gardens, Gt. Yarmouth

South of the Wellington Pier

The bandstand in Wellington Gardens was a most attractive feature: it had a series of statues of muses along the top, young women, each playing a different musical instrument. It was demolished in the Second World War. The model village and crazy golf course stand on its site.

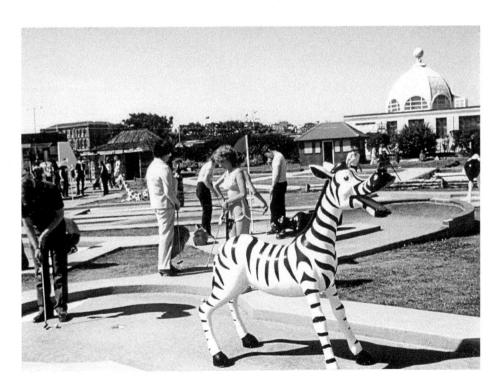

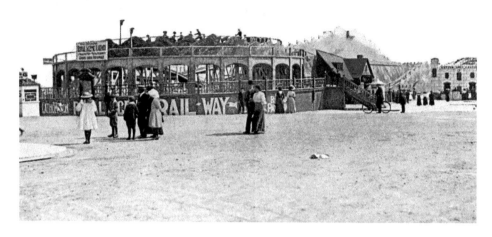

The Pleasure Beach

The Scenic Railway opened in the early years of the twentieth century, and brought to the southern end of the sea front the thousands of holidaymakers who had previously congregated around the area of the Britannia Pier. Rides, from the sedate to the adventurous, still dominate the scene at Yarmouth Pleasure Beach, which regularly features in lists of the 'top tourist attractions in England'.

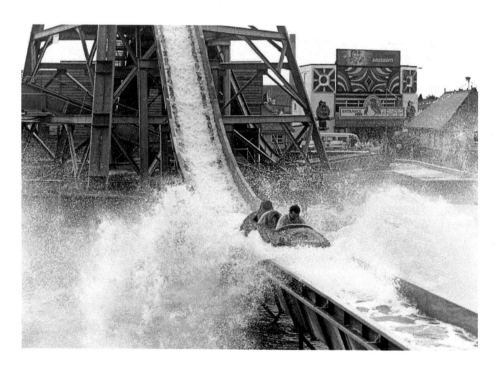

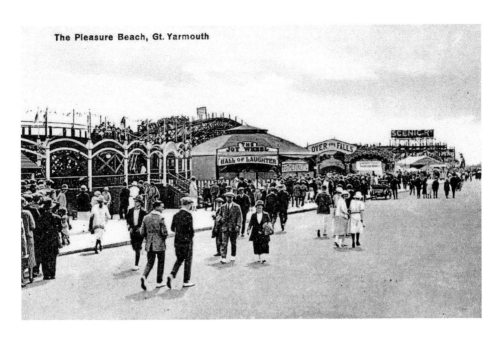

The Pleasure Beach, Gt. Yarmouth

All the Fun of the Fair

As the Ward Lock Guide of 1906 says, 'From sunrise to sunset there is no time to be dull in merry, moving, whirling Yarmouth, and indoor entertainments to keep the ball rolling when the stars look down upon the deserted sands'. This is just as true over a century later – and long may it continue. Yarmouth needs its visitors and knows how to make them welcome.

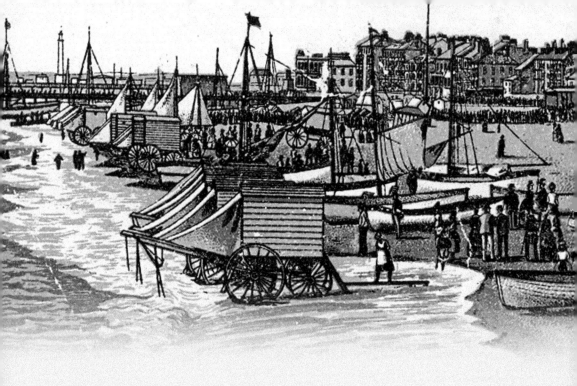

chapter 5

On the Beach

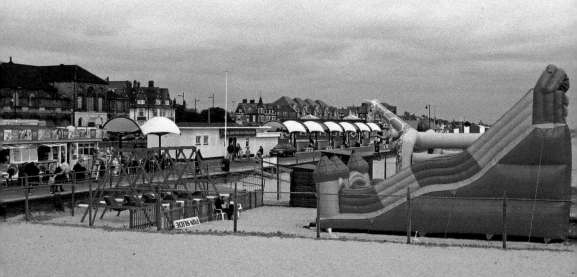

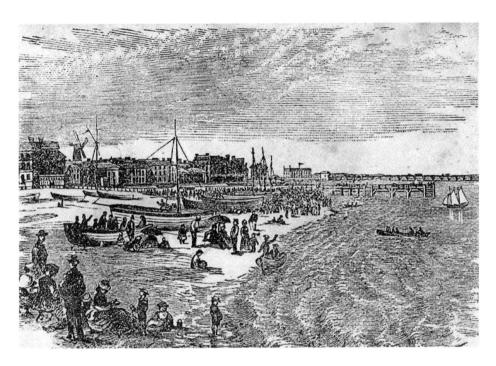

A hundred years of holidays

Images in this book capture changes in the use of the beach over the years. A century ago, bathing machines were an essential part of the beach scene, so that people could change in privacy and plunge straight into the water. There were also many boats drawn up on the beach. Today the scene is much less crowded and the emphasis is on deck chairs and bouncy castles.

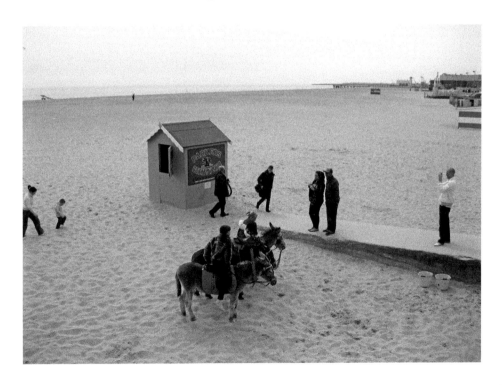

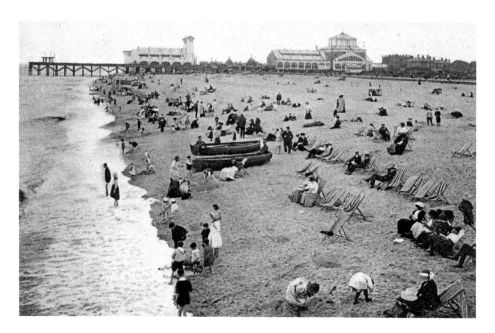

'What we did on our holidays'

'Games and shows, photographers and fortune-tellers, phrenologists and "penny-in-the-slots" are as plentiful as blackberries in autumn; the populace are at play in the most spacious, healthy and free of all playgrounds in England, enjoying themselves hugely, throwing heart and soul into the exhilarating work of squeezing into the day all the fun and joy it can possibly hold.' (*Ward Lock Guide*, 1906.)

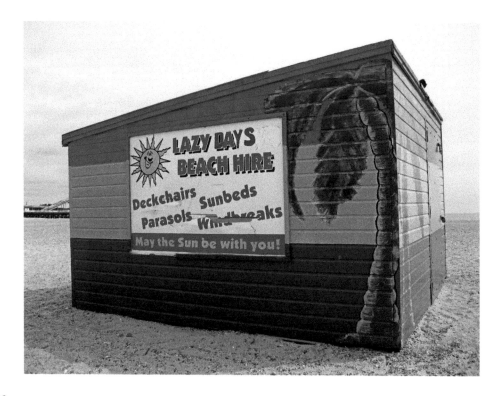

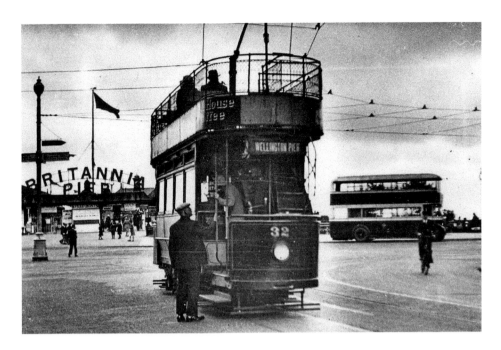

Trams and buses in front of Britannia Pier

The electric tramways in Yarmouth opened in 1902; an earlier horse-pulled tramway had run to Gorleston since 1875. Even in the 1930s, a tram ride from the north end of Yarmouth to the Wellington Pier cost only two pence, and a trip from the top of Regent Road to Wellington Pier cost just one penny!

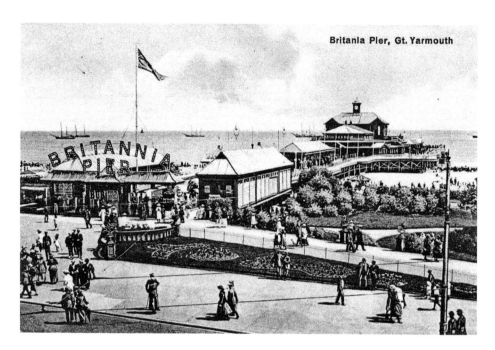

Britania Pier, Gt. Yarmouth

Britannia Pier

The Britannia Pier was opened in July 1858. It cost £6,000 to build. It has survived for over 150 years despite having suffered several major accidents in its time, including being struck by ships and also from fires.

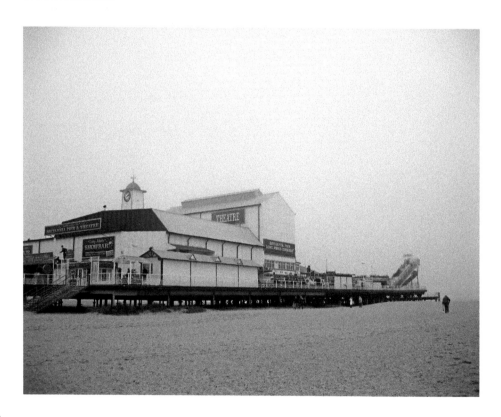

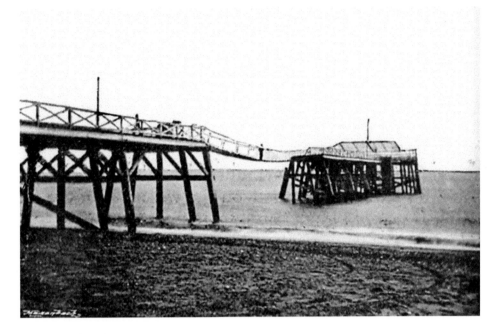

A Gap in the Pier

On 22 November 1868, the schooner *Sea Gull* went through the pier, carrying away 100ft. The photograph shows the rope bridge which was temporarily thrown across the breach after the accident. The central section of the pier was again destroyed in the Second World War, this time in case the Germans landed here. As an appropriate reminder of those dark days, the pier features in an episode of *Dad's Army*!

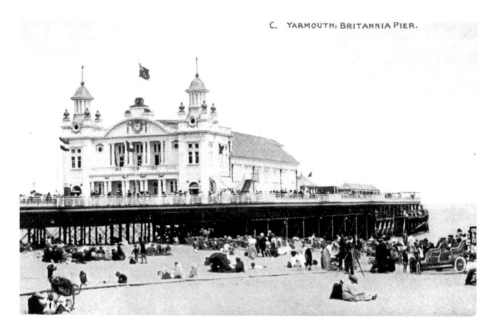

The Pier and the Beach

The first pavilion was built by one of Norfolk's most well-known iron foundries, Boulton and Paul of Norwich, and it had a dome in the centre and a minaret at each corner. This opened in 1902 and lasted just seven years. Another fire destroyed the second pavilion, which had a capacity of 2,000, on 20 April 1954. The present pavilion was built in 1958.

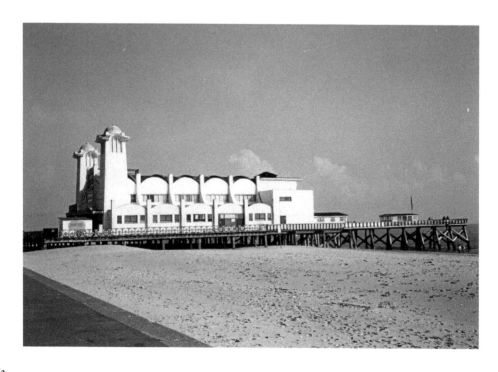

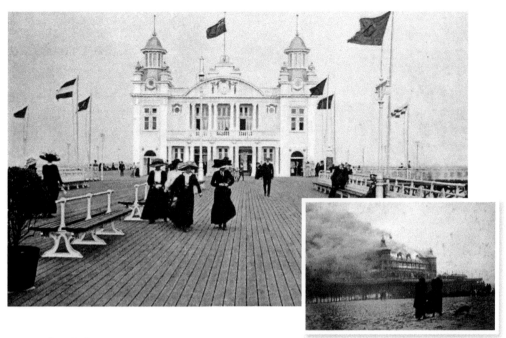

Dressed to kill on Britannia Pier

The 1902 pavilion was burnt down on 22 December 1909, allegedly by suffragettes. Leaflets urging 'Votes for Women' were found scattered around, so that the pier has played its part in the struggle for women's rights! It was replaced by a new pier, which was 810ft long, 125ft longer than the previous one.

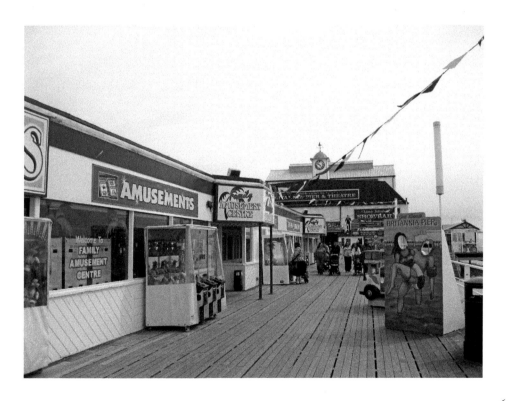

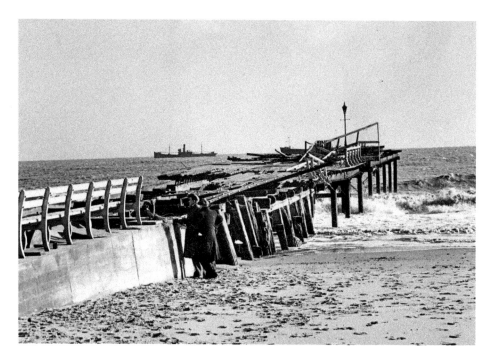

The Jetty

The Jetty between the two piers was originally for landing fish. It has been in use since the 1560s and extended several times afterwards. Later, it became a third pier with no amenities but with one great advantage over the other two for those careful with their money: the others charged two pence admission in the 1930s, but the Jetty was free! The picture shows the damage caused by the storms of 1953.

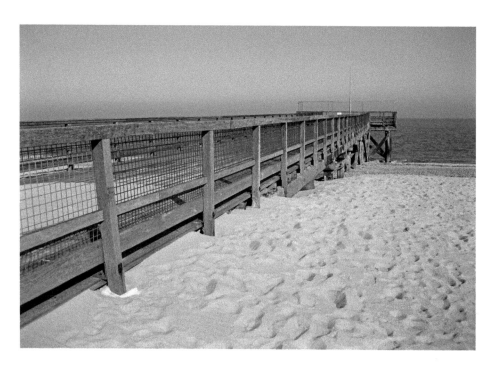

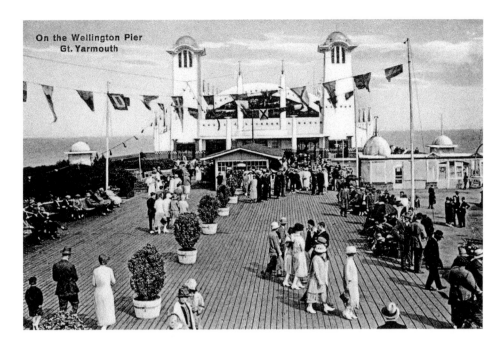

On the Wellington Pier
Gt. Yarmouth

The Wellington Pier

The Wellington Pier was built in 1853. It was rebuilt with a pavilion in 1903. John Goode ran the Wellington Pier between 1884 and 1899, when it was taken over by the Corporation; a combined ticket would allow you to visit the pier in the afternoon and go on to Goode's dancing establishment at Winton's Rooms in the evening. The pier was bought by the Corporation in 1900.

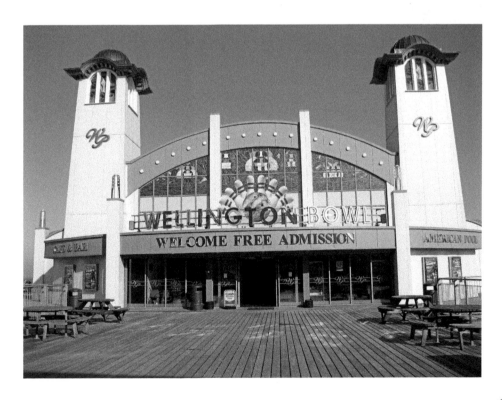

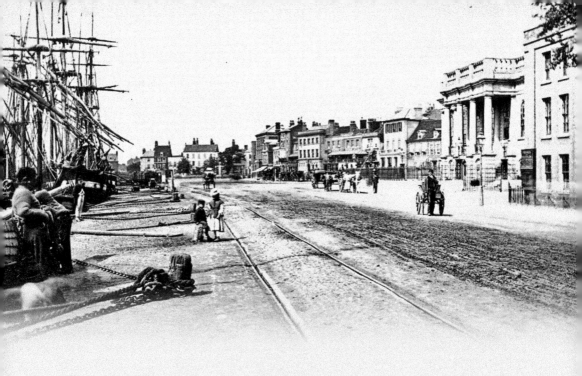

chapter 6

Quays and Bridges

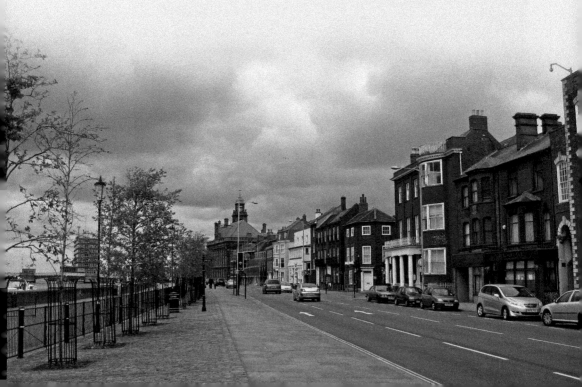

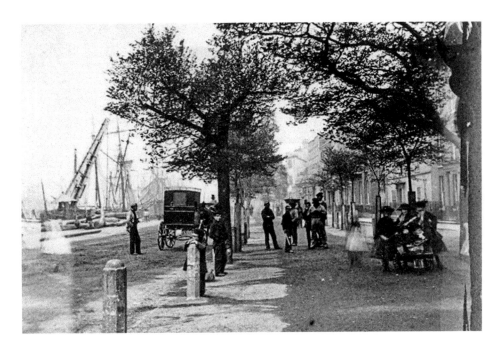

South Quay

This was the heart of the town in the eighteenth century. According to John Price, the keeper of the Bodleian Library in Oxford who came here as a tourist in 1757, 'so spacious is the quay that for part of the length there are two rows of limes forming a regular and pleasant line between'. Today, the trees are back.

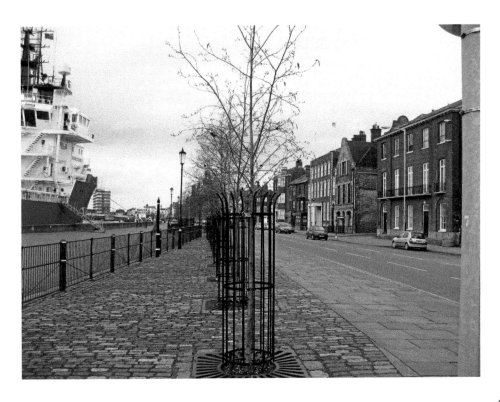

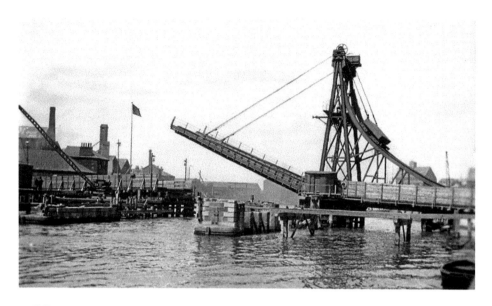

Building Haven Bridge

There has been a bridge across the river here for over 500 years, linking Yarmouth with Gorleston and ultimately to London. The present bridge was built in 1930 and more recently there has been a second crossing at Breydon. Many people think that the time has come for a third crossing further south to take the volume of traffic that the new Outer Harbour will bring to the town.

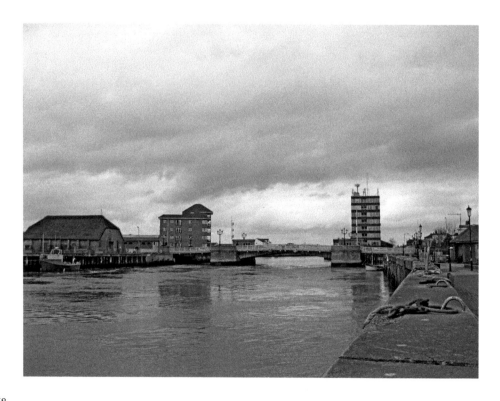

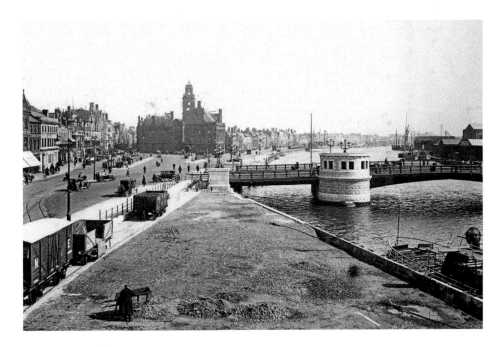

The Haven Bridge

Yarmouth's river has been its life-blood for over a thousand years. The bridge has to swing or lift to allow large ships to proceed up the river to Norwich. Norwich Cathedral and Castle were both built by the Normans using limestone from Normandy. This was brought by ship to Great Yarmouth and then off-loaded into barges for the journey up the river. What a busy place the quay must have been during those far-off times!

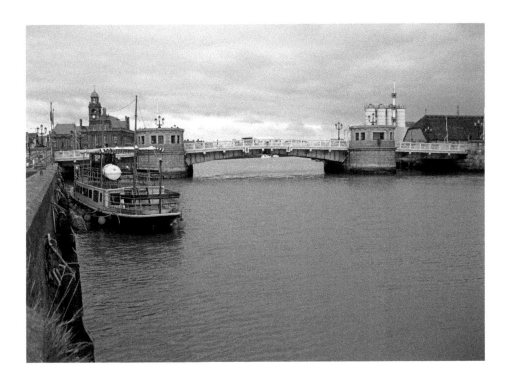

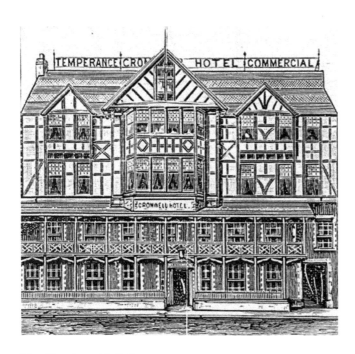

The Hotel on Hall Quay

As the sign makes clear, the Cromwell was a temperance hotel, which means that no alcohol was served. It boasted a dark room and was a meeting place for several late-Victorian societies of photographers and also of cyclists. In 1906, rooms here cost two shillings a night! The nearby Star cost sixpence a night more, but was obviously more successful as it has since taken over the old Cromwell.

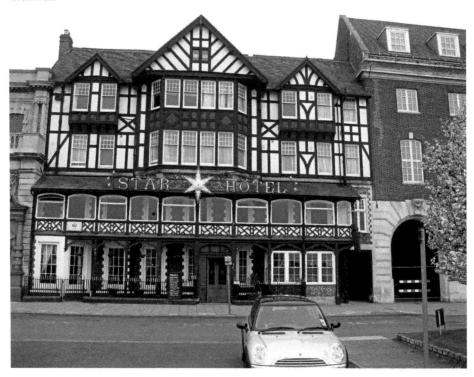

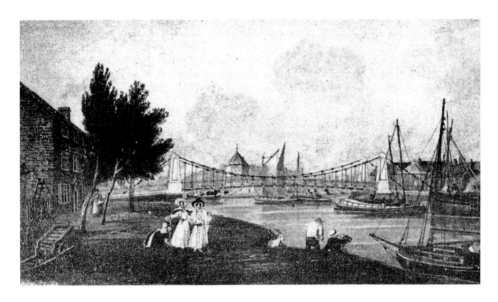

The Old Suspension Bridge

The suspension bridge was built by Robert Cory in 1829. In 1845 there was a great disaster here: a crowd of people including a large number of local children gathered on the bridge to watch a circus clown named Nelson (but presumably no relation of Norfolk's great sailor hero) proceed up the river in a tub drawn by four geese. The bridge collapsed and seventy-nine people, mostly young children, were drowned.

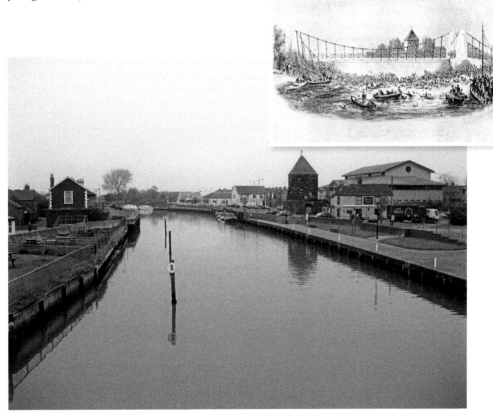

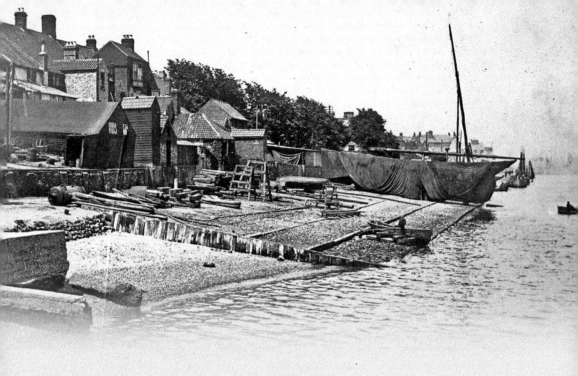

Gorleston – Norfolk's Best Kept Secret

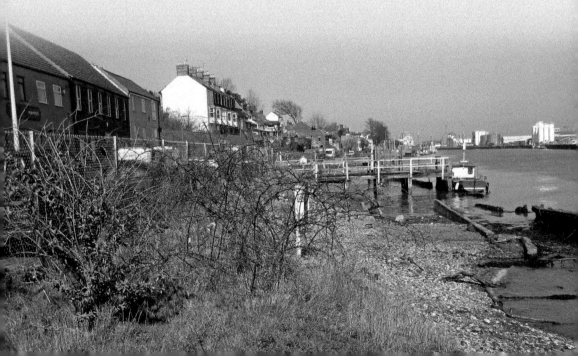

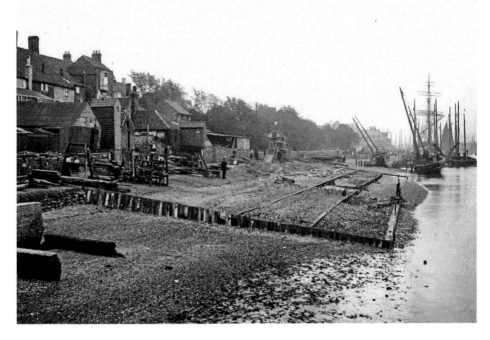

Shipbuilding

Gorleston was not just a holiday town, it had an important industrial side to it as well and there were many shipbuilding and repairing yards. The activity has completely gone today, but one or two parts of the sea front retain a flavour of their past.

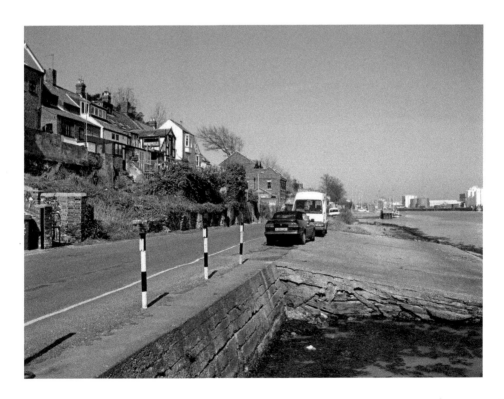

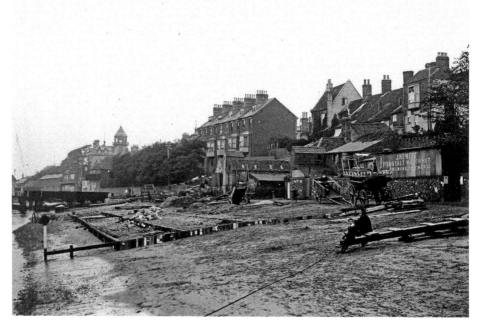

Darby's Hard

The most well known of the shipbuilding firms was probably that of Hewitt's. The firm moved here from Barking in 1867. Their ships were distinguished by a square blue flag, hence the name of the very popular pub The Short Blue in Gorleston today!

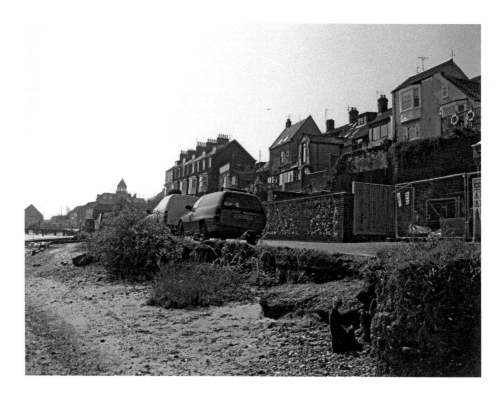

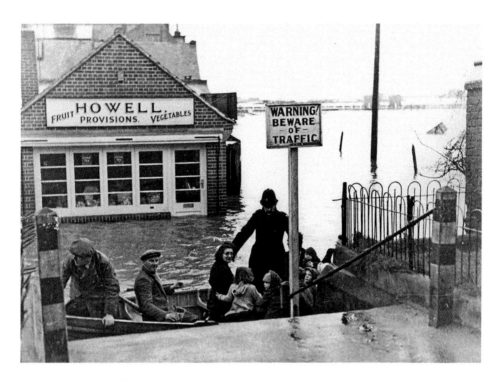

Beach Road in 1953

The 1953 floods hit the low-lying parts of Gorleston and Southtown especially hard. On just the one night more than 1,000 were flooded in Gorleston alone. Ten people lost their lives, mainly the elderly trapped in their homes.

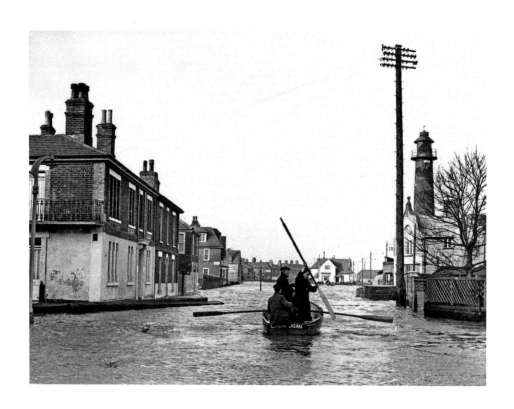

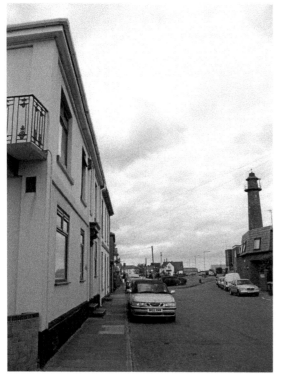

Pavilion Road Under Water
Gorleston lighthouse can be seen in the striking image of the 1953 floods, showing the rescue of people stranded in their homes. The floods produced at least one local hero, Frederick Sadd, who was awarded the George Medal for his bravery that night.

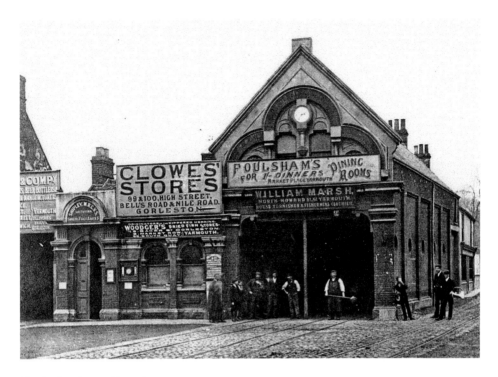

Gorleston Tram Depot

The tram depot, opposite the Feathers, did not last long, being replaced by the Carnegie Library in 1907. This was itself demolished in the 1970s to make way for the new library, which opened in 1977. Only the name and the sign of another public house beyond the library – the Tramway – reminds present-day Gorleston residents of the trams.

Koolunga

Like many Gorleston houses, this was built by a sailor home from the sea and commands a lovely view of the harbour. Presumably the name was inspired by happy memories of travel as Koolunga is in Australia. The house was originally built in 1826. After serving various uses, it was converted into flats in 1990.

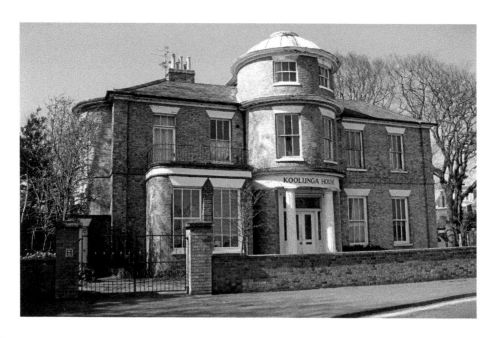

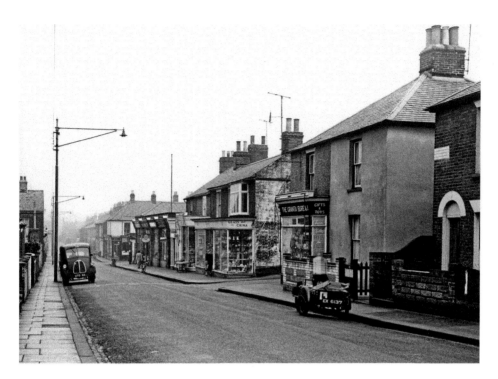

Bells Road

Bells Road is named after the Bell family of Gorleston; John Sayers Bell was a prominent local brewer. The road was once the busiest shopping street in the town after the High Street and was crowded with holidaymakers in the summer looking for bargains – it was known locally as 'Fleece Street'! Shops here included a post office and a Co-op.

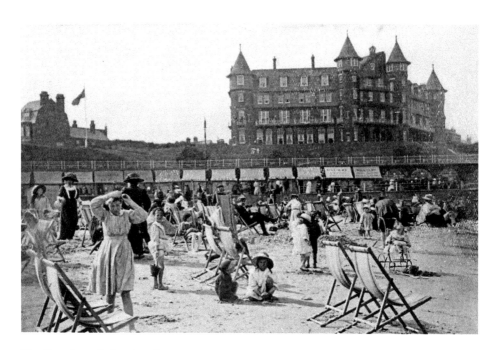

The Beach and the Hotel

The grand Cliff Hotel opened in 1898. It was designed by the Norwich architect George Skipper. From 1910, a *Guide* reads, ' It is difficult to realize that on the spot where the Cliff Hotel now stands, a rustic windmill waved gaunt arms a few years ago over an expanse of wild heath'. The life of the hotel was a short one, however, and it was destroyed by fire on Boxing Day 1915.

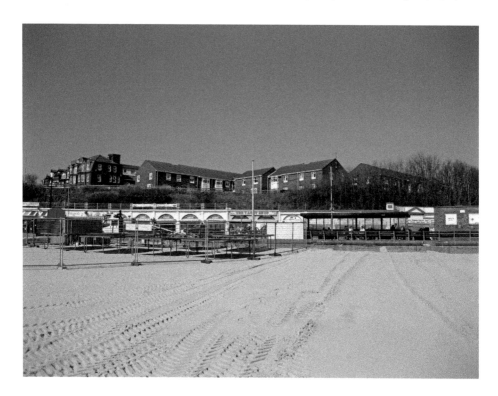

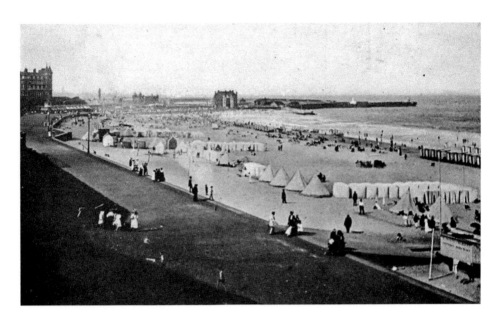

The Beach from the Cliffs

The Pier Hotel opened in 1897, replacing a fishermen's public house, the Anchor and Hope. It provided accommodation and a restaurant for the new tourists to the town. As one guide said, 'The firm and broad sands, so dotted with cone-shaped tents as to bear a striking resemblance to a military camp, are unvisited by minstrel or pierrot, organ-grinder or hawker.... The tents, which can be hired at a very reasonable price, are a very pleasant feature of seaside life at Gorleston'.

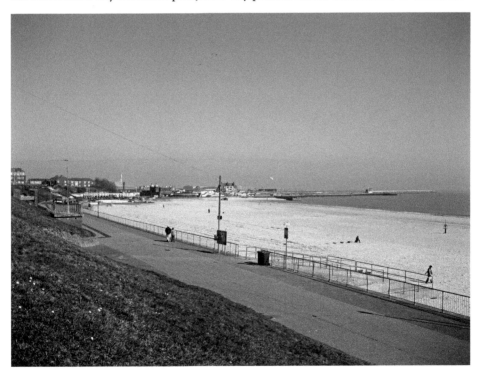

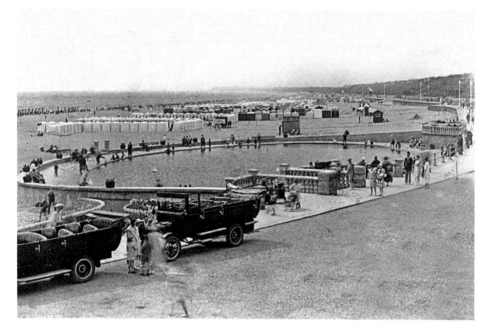

The Model Yacht Pond

The Yacht Pond was built in 1926, as part of a series of schemes by the Borough Council to supply work to the unemployed. It makes a happy souvenir from a distressing time of mass unemployment and poverty, and is still well used by local enthusiasts.

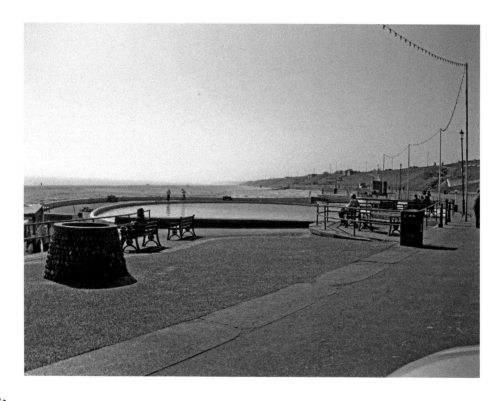

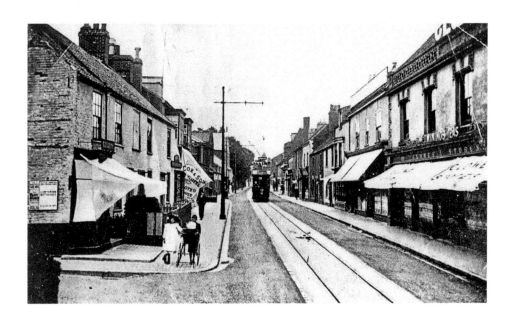

High Street with Tram

Gorleston was linked by tram with the Haven Bridge in the centre of Yarmouth as early as 1875; for the first twenty-five years the trams were pulled by horses. The line was electrified in 1900. There was never a tramline across the Haven Bridge so passengers had to walk across and board another tram on the other side of the river!

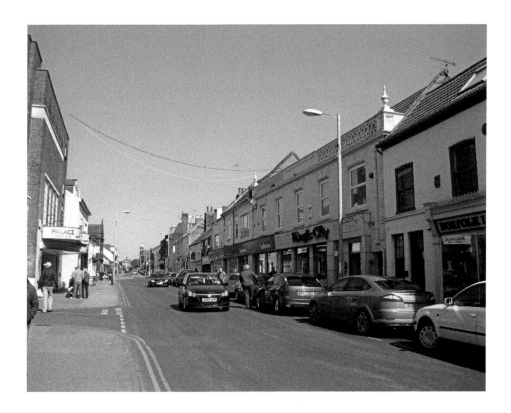

A Dutch Gable in Gorleston

This form of gable is taken from a style used in Holland. There are close links across the North Sea between Yarmouth and the Netherlands, only ninety miles away, and when Germany invaded Belgium and the Netherlands on 10 May 1940, the sound of the guns could be heard like thunder here in Gorleston!

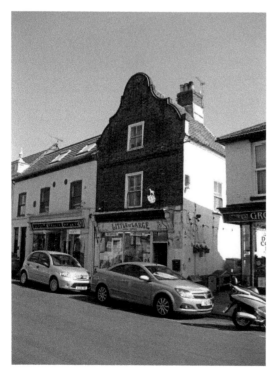

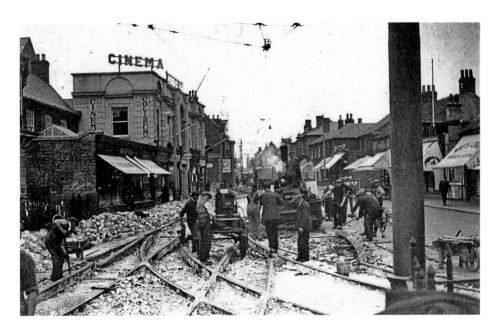

The Centre of Gorleston

Gorleston had three cinemas at its peak. The Coliseum Cinema, seen here, opened in Gorleston High Street in 1913, the same year as Filmland in Beach Road. It closed down in 1970. There was another cinema in the High Street, the Palace, which became a bingo hall in 1964.

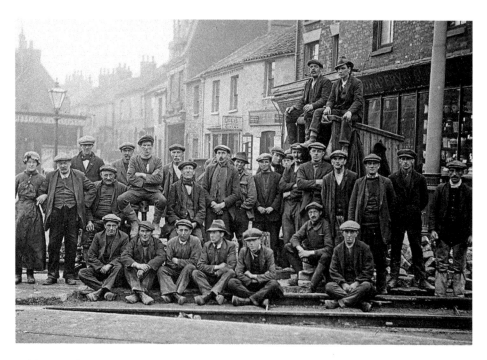

Taking up the Tram Lines

This is the northern end of Cliff Hill. Note the advertisement for the cinema in Beach Road, the Louis Quartorze, which had been built as Filmland. Under its later name, inevitably known to locals as the 'Lousy Quarters' – unfairly as it was very far from being a fleapit cinema! It closed before the Second World War.

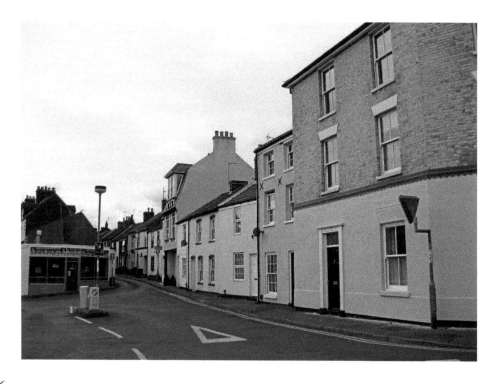

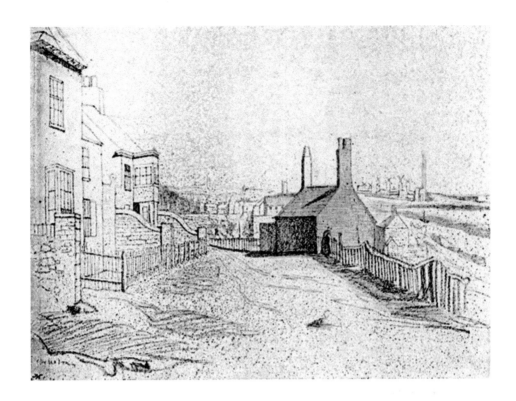

Cliff Hill

We are looking along one of the loveliest streets in Norfolk, running along the side of Gorleston 'cliff' and with beautiful views of the harbour – we could almost be in a Cornish or Devon fishing village. Beachmen and pilots were the first to build houses here from the early nineteenth century. There is a distant view of the Nelson monument in Yarmouth from this street.

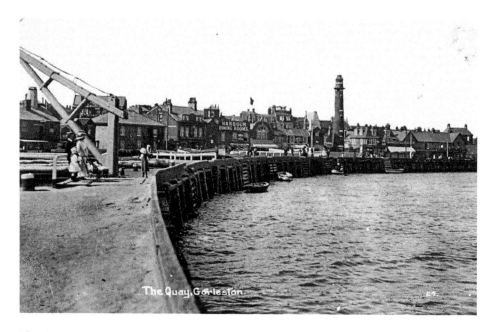

The Quay

Gorleston Lighthouse was built by Great Yarmouth Port and Haven Commissioners in 1887 to direct ships into the mouth of the harbour. The dramatic curve in the river can be seen well in these two images. Older residents still recall the unique scent of the area, the fragrant odour of pitch-pine which was unloaded along the river.

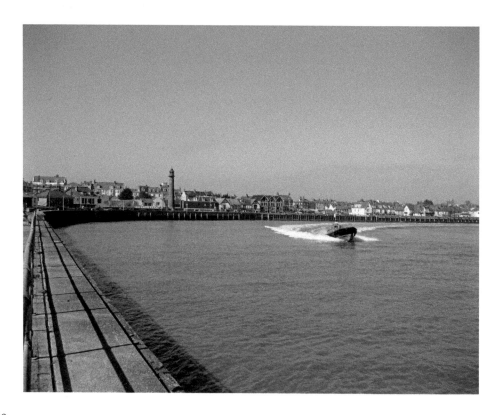

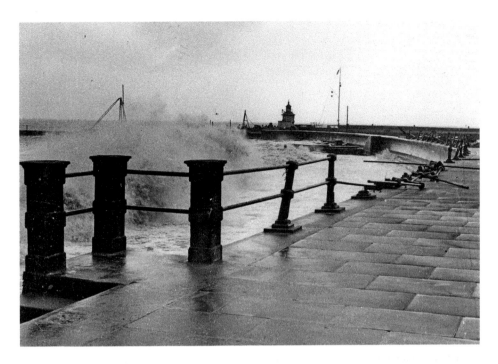

The Storm and the Calm

The harbour mouth seems calm enough on most days but can be difficult and dangerous during a severe storm; many ships have been lost on this coast, sometimes with great loss of life. One was the *Maggie Williams* which was smashed against Gorleston breakwater in 1902. It is said that the top of one of her masts can still be seen at low tide.

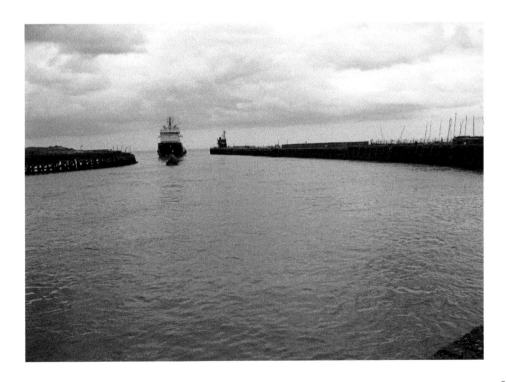

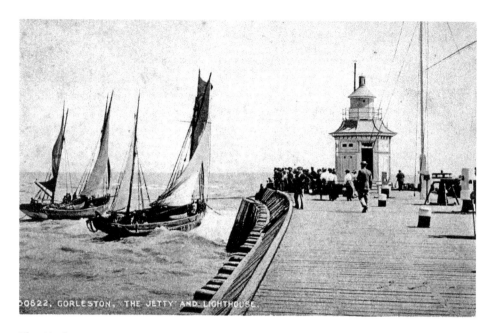

00622. GORLESTON. THE JETTY AND LIGHTHOUSE.

The Harbour

It is still possible, as it was a century ago, to hear 'the sound of the deep sea booming beyond the two piers that protect with their sheltering arms the harbour mouth at Gorleston'. There have been many attempts to fix the mouth of the river Yare over the centuries. The present outlet was designed by a Dutch engineer, Joos Johnson, who strengthened the sharp bend in the river by hedging it with stakes, piles and brushwood, giving it its present name of Brush Quay.

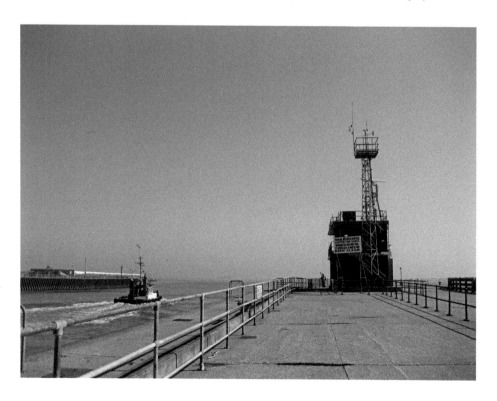

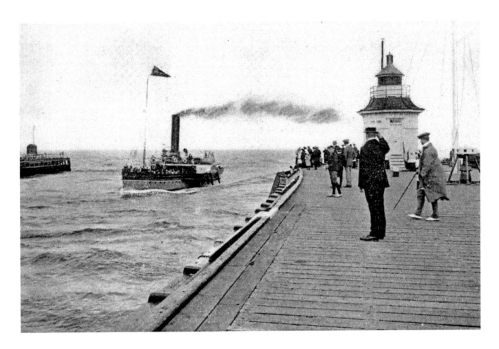

The Lighthouse at the Harbour Mouth

The pier is often called the Dutch Pier in honour of Johnson's achievement. The pepper-pot lamp-house saw over a century of service before it was replaced in 1963. There used to be spaces between the wooden beams of the south face of the pier, known locally as 'Cosies', that were, ideal for fishing from, or for cuddling one's girl: sadly, they disappeared when the whole pier was faced with concrete.

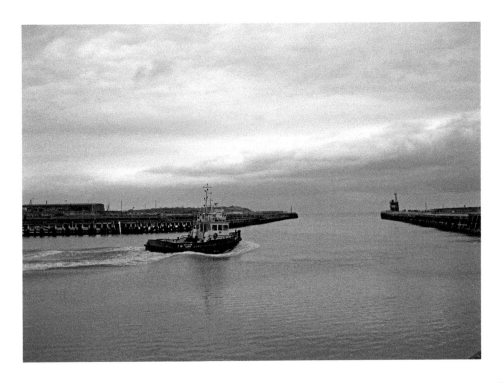

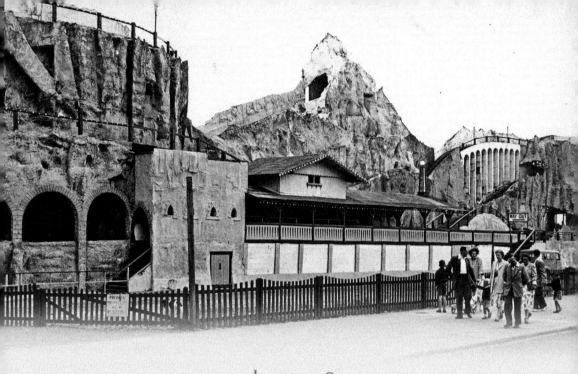

The Future of Great Yarmouth

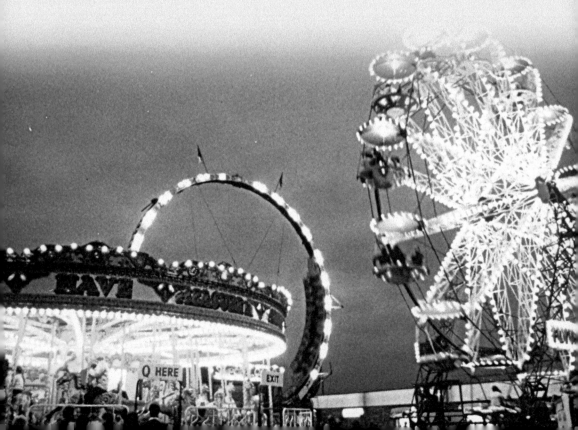

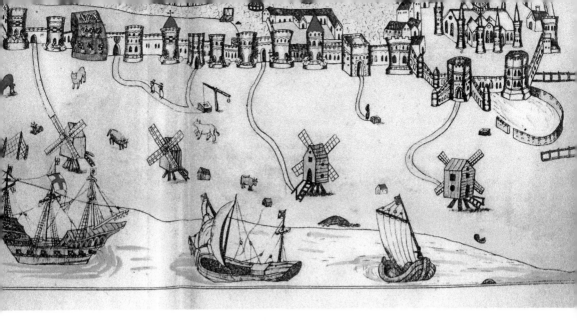

Wind Power, Old and New

There is nothing new about the idea of harnessing the energy of the wind that blows across the North Sea, and the map, drawn in about 1580, shows the windmills on Yarmouth beach at that time. Today, the turbines are not on the beach but in the sea, at Scroby Sands.

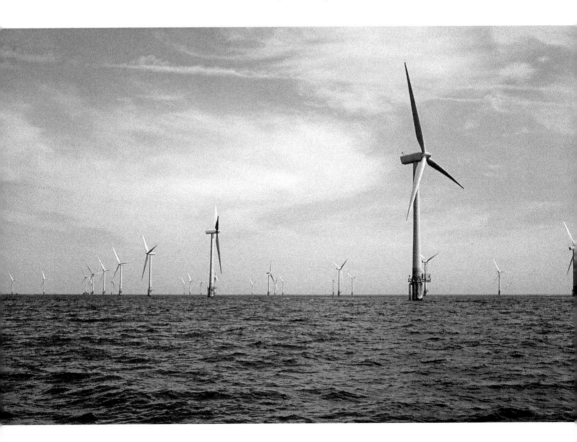

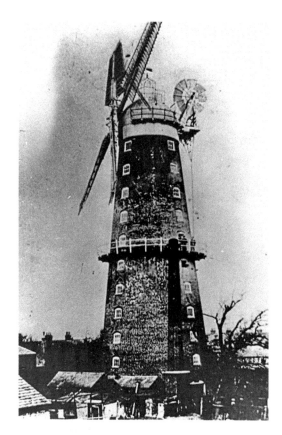

The Tallest Windmill in the World

High Mill in Southtown was an incredible eleven storeys in height – count the windows! With its lantern on top, it was 135ft high. The base was 46ft in diameter, so large that a road ran through it so that farm carts could unload corn and load flour actually inside the mill. The mill was sold off in 1904 for a mere £100, and the bricks were used for the houses that make up High Mill Terrace. Two of the houses have red chimney pots and these mark the actual site of High Mill.

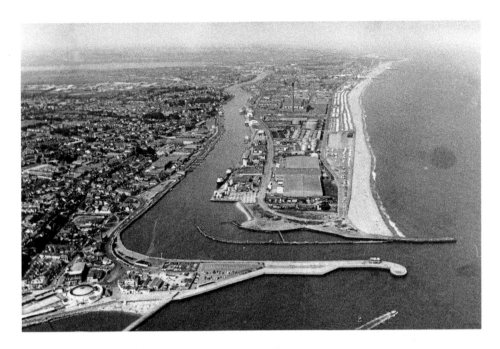

Looking East: Great Yarmouth Harbour

The shape of the harbour mouth, with its sharp bend to the east, was finally fixed in the sixteenth century; there had been six earlier attempts to create a permanent haven. The aerial photograph taken in 2009 by Mike Page shows how the new Outer Harbour has created the first dramatic change in this landscape for 450 years.

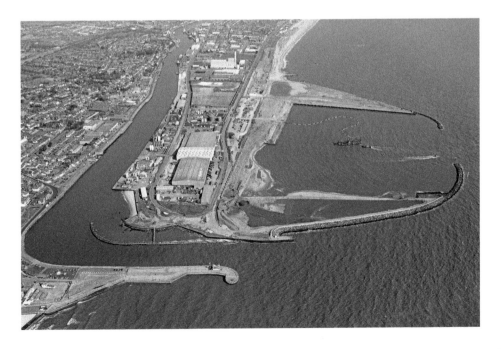

Acknowledgements

The archives of the Great Yarmouth Borough Council are held at the Norfolk Record Office. They include an enormous photographic archive dating from the 1860s to the present day. All but three of the historic photographs and nine of the modern ones are taken from this source or from the records of the Yarmouth Council Transport Department, which was later privatised. Three historic photographs are from the Norfolk County Council archives, all in the Norfolk Record Office. The stunning final image in the book was taken by Mike Page. All the other modern photographs are by the author.

I am extremely grateful to the Great Yarmouth Borough Council, to the Norfolk Record Office, County Archivist Dr John Alban and to Mike Page for permission to use the images in this book.

With thanks to Norfolk Record Office for the following archive pictures. The page number is given in brackets, and the reference to the upper picture on each page is given first:

(6) NRO, ACC 2004/307-FM (7) NRO, Y/D 36/8/1; FM (8) NRO, Y/TC 86/12/54; NRO, ACC 2004/307 (9) NRO, Y/D 94/39; FM, (10) NRO, BR 272/135; FM, (11) NRO C/SR 11/108; FM, (12) NRO, Y/BE 5/13; FM, (13) NRO, Y/TC 86/12/60; FM, (14) NRO, Y/TC 86/12/58; FM, (15) NRO, Y/D 71/7; FM, (16) NRO, Y/D 71/5; FM, (17) NRO, Y/TC 86/12/55; FM, (18) NRO, Y/D 36/2/5; FM, (19-21) NRO, Y/D 71/4; FM (22) NRO, BR 272/142; ACC2004/307 (23) NRO, Y/TC 86/12/77; ACC 2004/307 (24) NRO, BR 272/135; FM (25) NRO, BR 272/136; FM (26) NRO, ACC 2004/307; FM (27) NRO, ACC 2004/307; ACC 2004/307 (28) NRO Y/D 94/39; ACC 2004/307 (29-31) NRO, Y/D 94/39; FM (32) NRO, Y/TC 86/12; FM (33) NRO, Y/BE 5/11/2; FM (34) NRO, BR 272/142; ACC 2004/307 (35) NRO, ACC 204/307; FM (36) NRO, Y/D 36/4/7; FM (37-39) NRO, Y/BE 5/14; FM (40) NRO, Y/D 36/4/10; FM (41) NRO, Y/D 36/4/1; FM (42) NRO, BR 272/129; FM (43) NRO, Y/D 37/1; FM (44) ACC 204/307; FM (45) ACC 204/307; FM (46) NRO, Y/D 71/5; FM (47) NRO, ACC 204/307; FM (48) NRO, ACC 204/307; FM (49) NRO, Y/BE 5/14: FM (50) NRO, C/WT 1/6/1/5; FM (51) NRO, Y/D 36/3/4; FM (52) NRO, BR 272/142; FM (53) NRO, Y/D 36/2/9; ACC 2004/307 (54) NRO, ACC 2004/307 (55) NRO, Y/D 36/3/3; ACC 2004/307 (56) NRO, Y/D 71/8; FM (57) NRO, Y/D 71/7; FM (58) NRO, Y/D 71/5; FM (59) NRO, BR 272/142; FM (60) NRO, Y/D 36/3/13; FM (61) NRO, Y/D 94/39; ACC 2004/307 (62) NRO, Y/D 36/2/11; ACC 2004/307 (63) NRO, Y/D 36/2/11; Y/TPL 3/2; FM (64) NRO, Y/BE 5/11/2; FM (65) NRO, Y/D 36/3/5: FM (66) NRO, Y/TC 86/12/57; FM (67) NRO, Y/TC 86/12/67; FM (68 and 69) NRO, Y/BE 5/14; FM (70 and 71) NRO, Y/D 94/39; FM (72-4) NRO, Y/TC 81/25; FM (77) NRO, BR 272/136; FM (78 and 79) NRO, ACC 2004/307; FM (80 and 81) NRO, Y/D 71/5; FM (82) NRO, Y/BE 5/14; FM (83) NRO, BR 272/135; FM (84) NRO, ACC 2004/307; FM (85 and 86) NRO, BR 272/138; FM (87) NRO, Y/D 94/39; FM (88) NRO, Y/TR 682/2; FM (89) NRO, Y/BE 5/11/2; FM (90) NRO, Y/TR 682/1; FM (91) NRO, Y/D 71/5: FM (92) NRO, Y/D 36/2/2; ACC 204/307 (93) FM (94) NRO, C/WT 1/6/1/5; FM (95) NRO, ACC 2004/307; Mike Page